T0009526

BEST OF
POP MANGA
COLORING BOOK

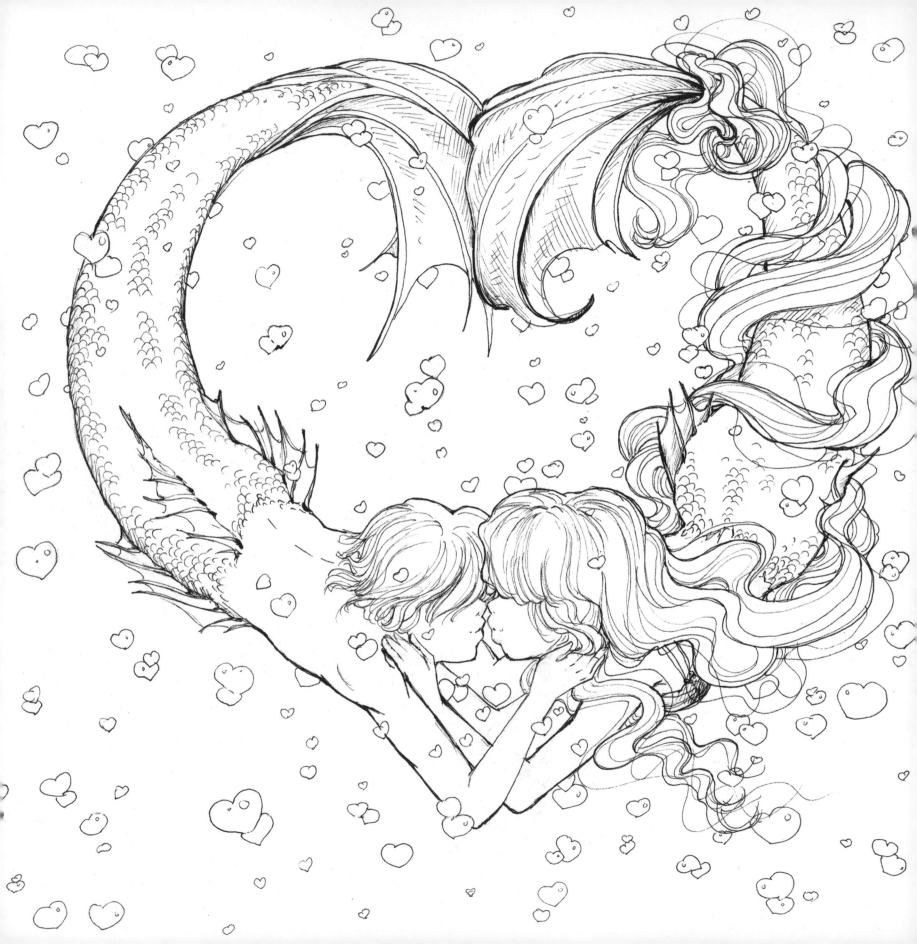

BEST OF
POP MANGA
COLORING BOOK

CAMILLA d'ERRICO

WATSON · GUPTILL
CALIFORNIA | NEW YORK

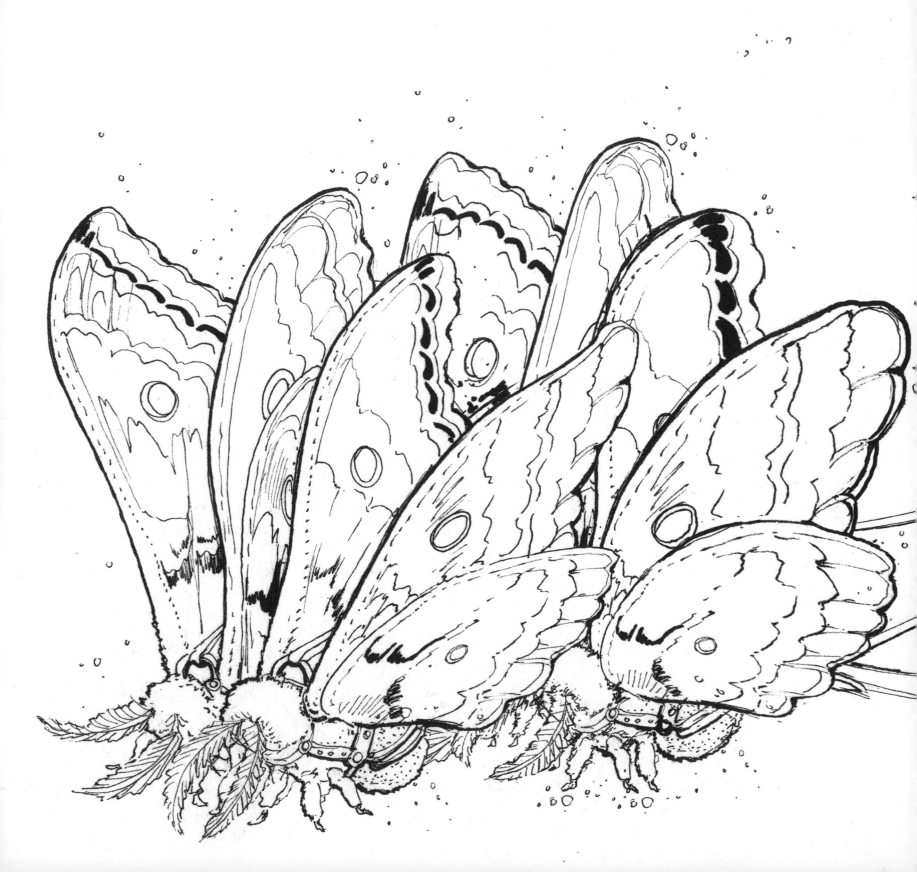

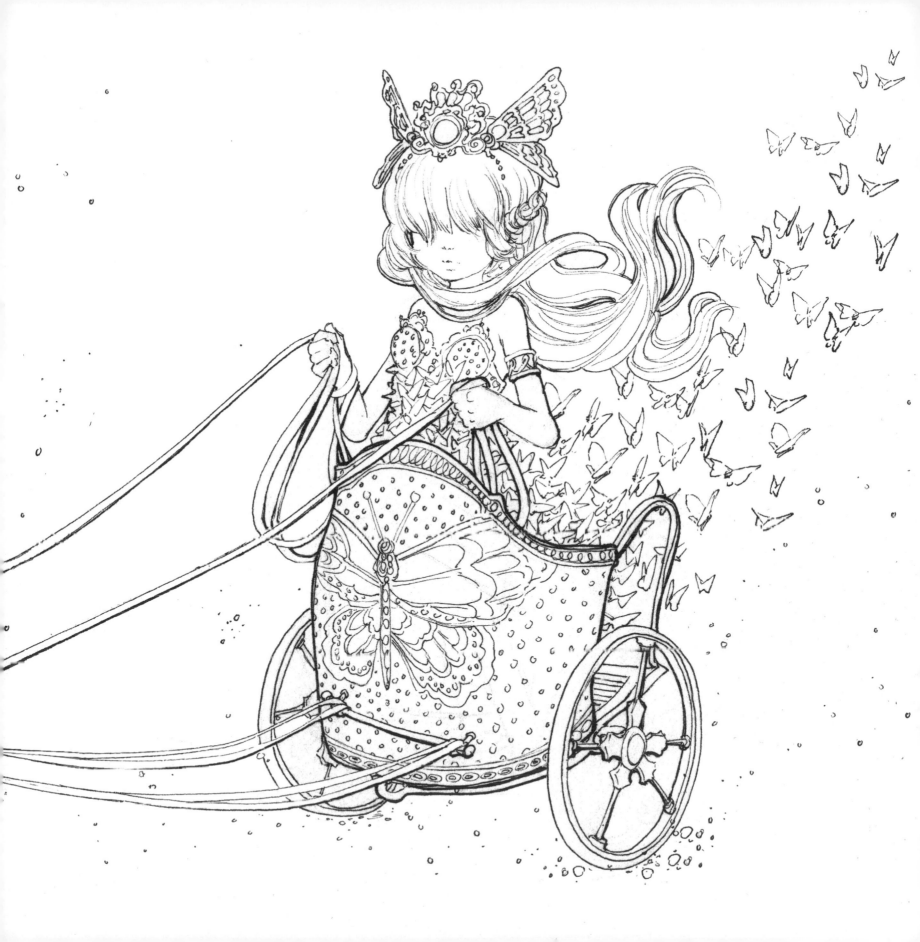

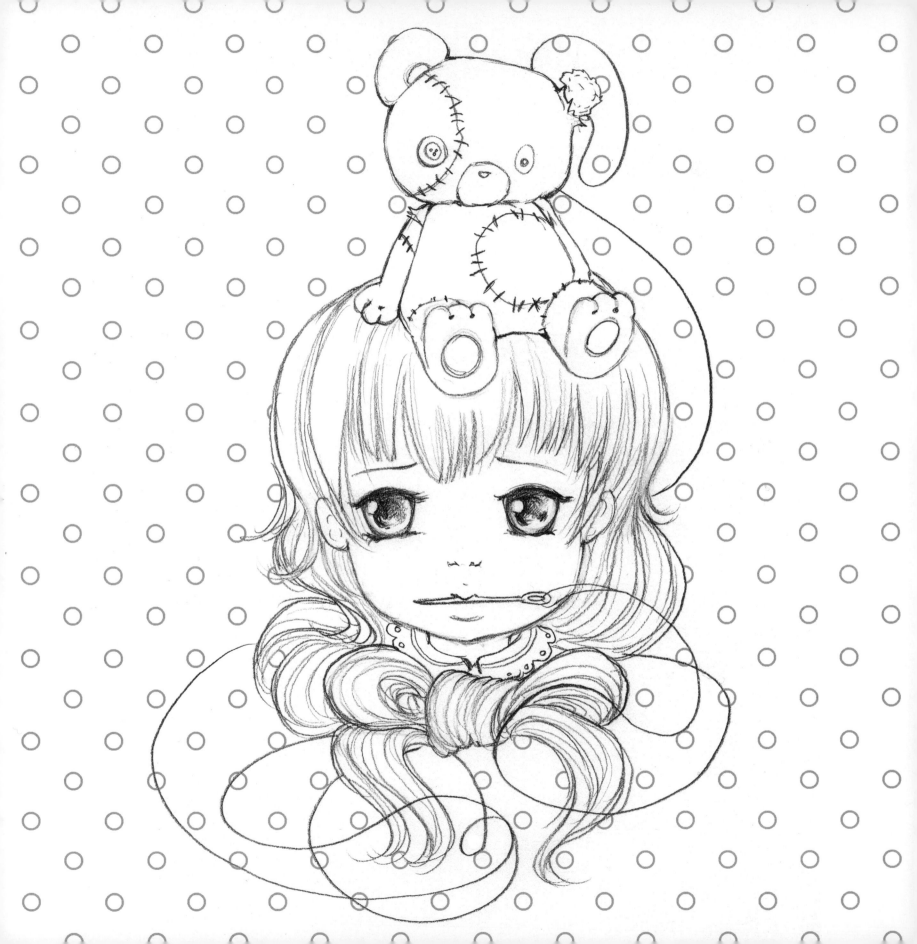

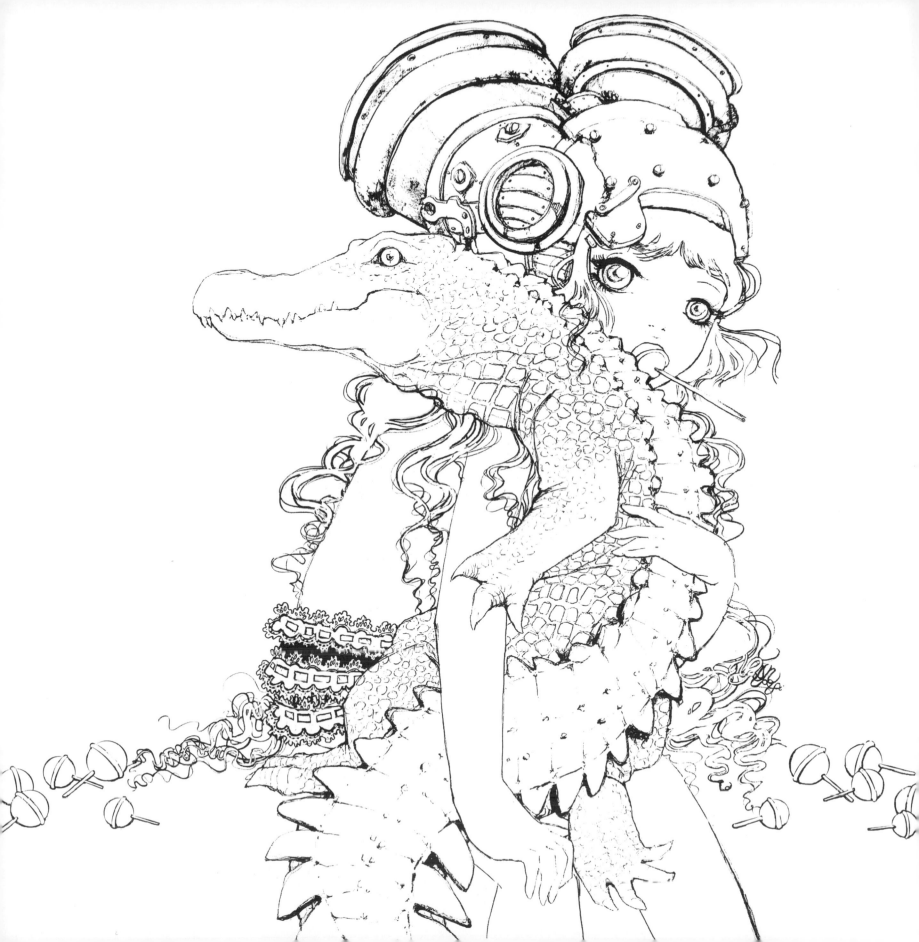

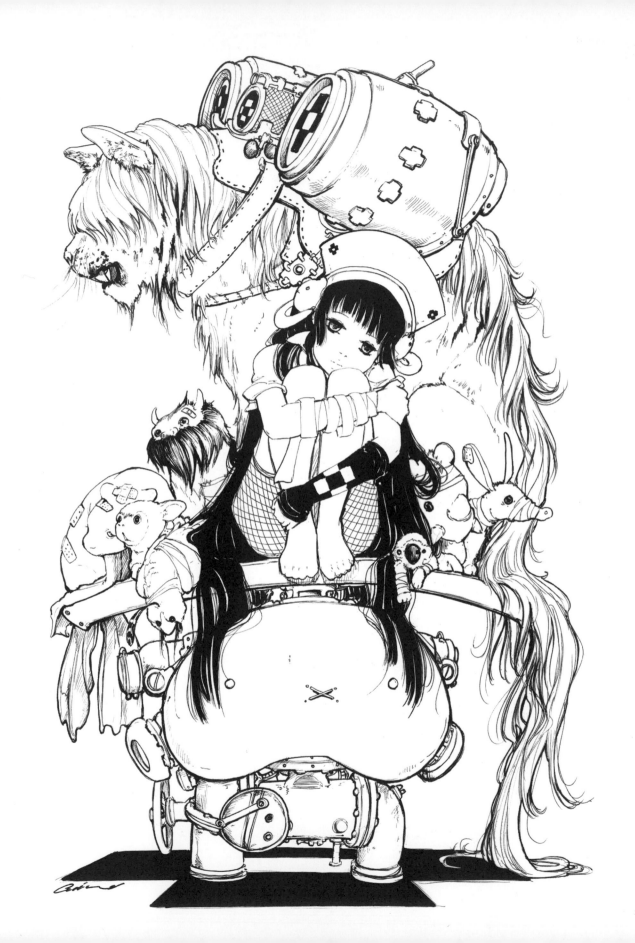

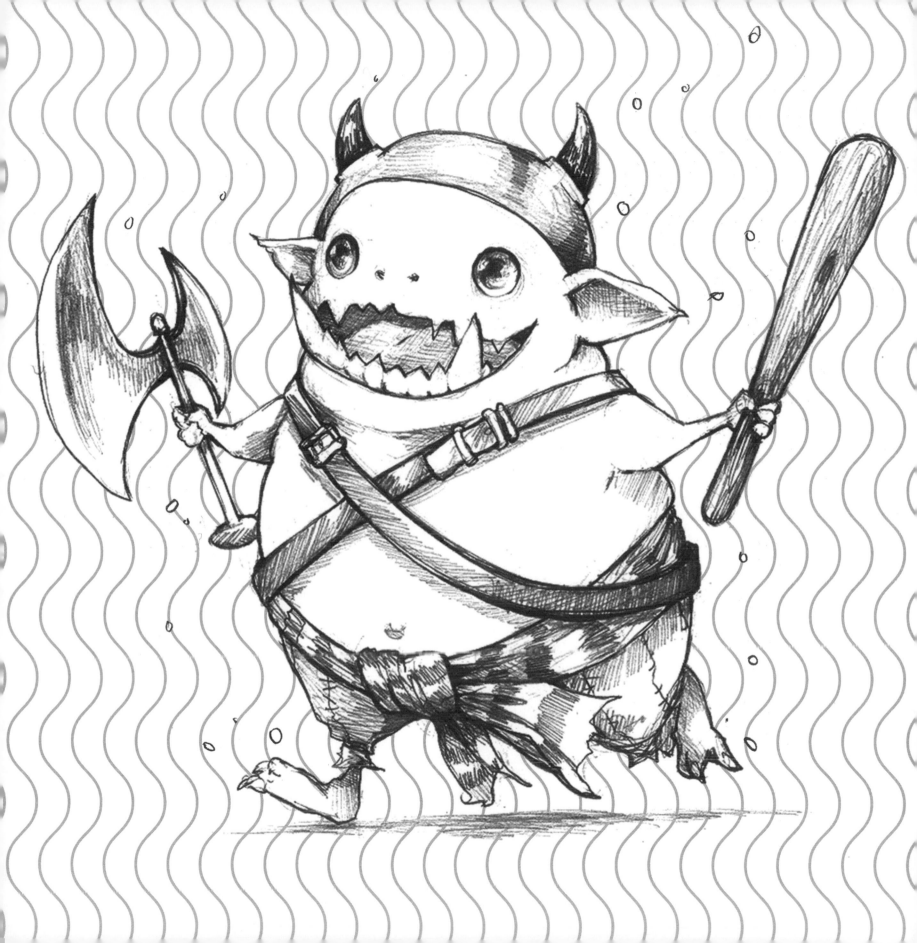

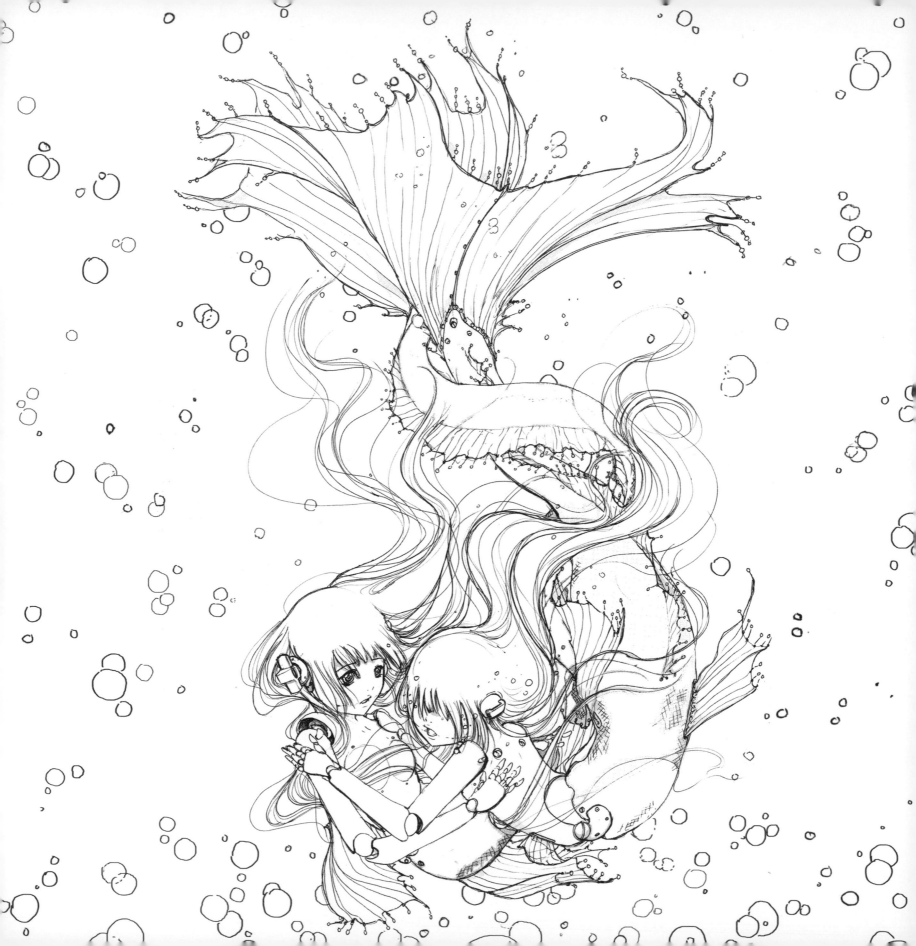

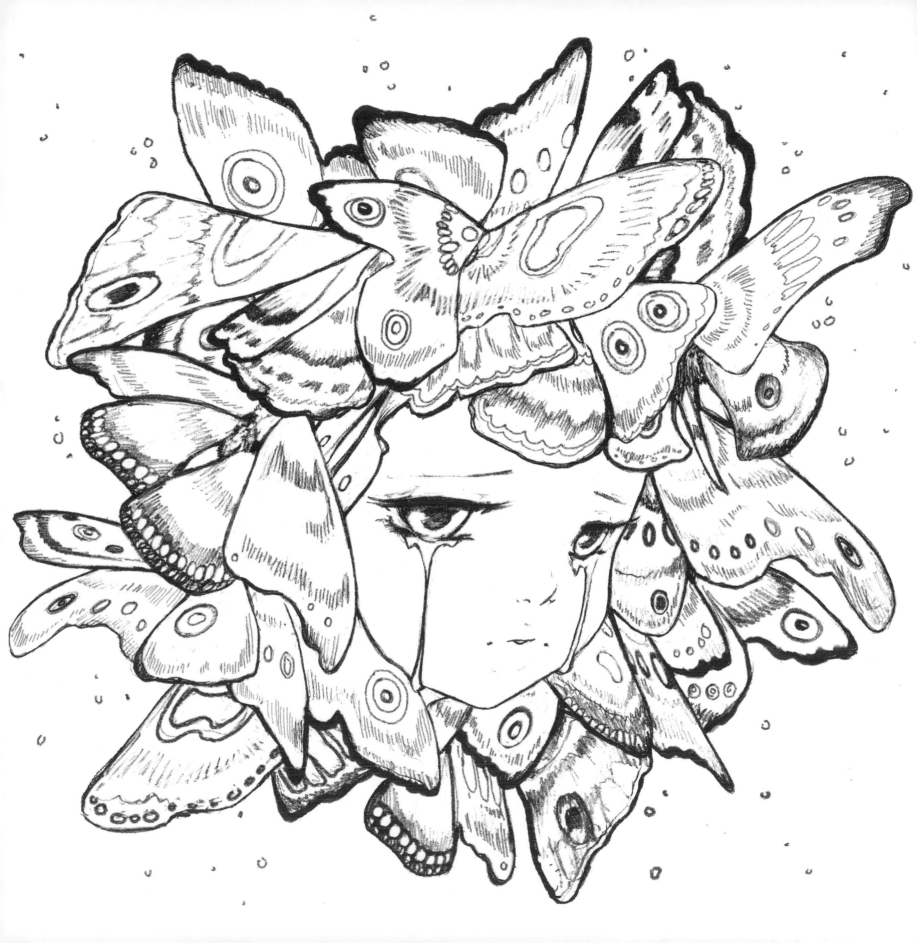

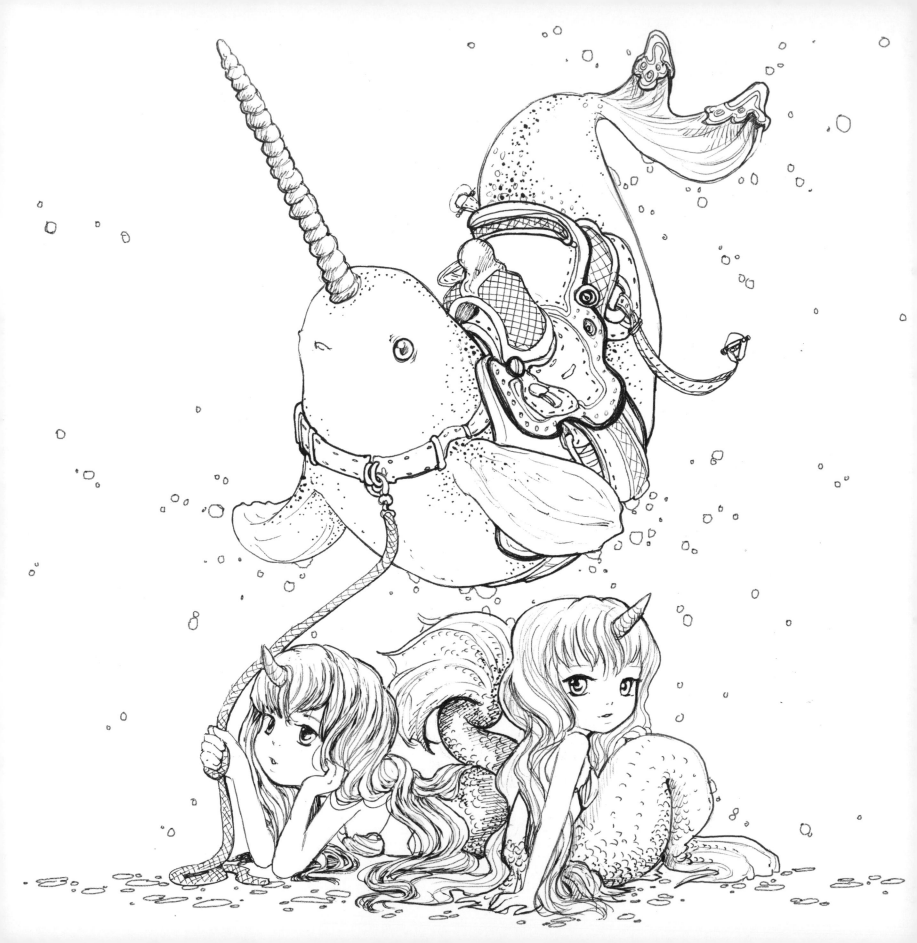

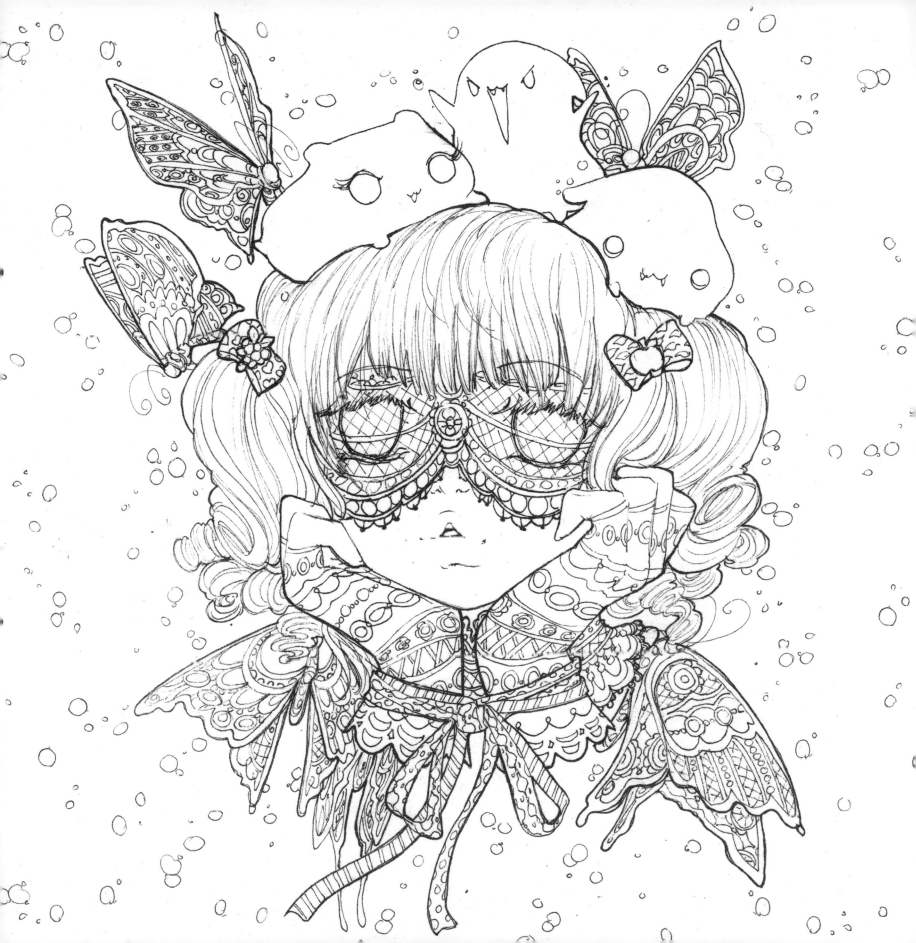

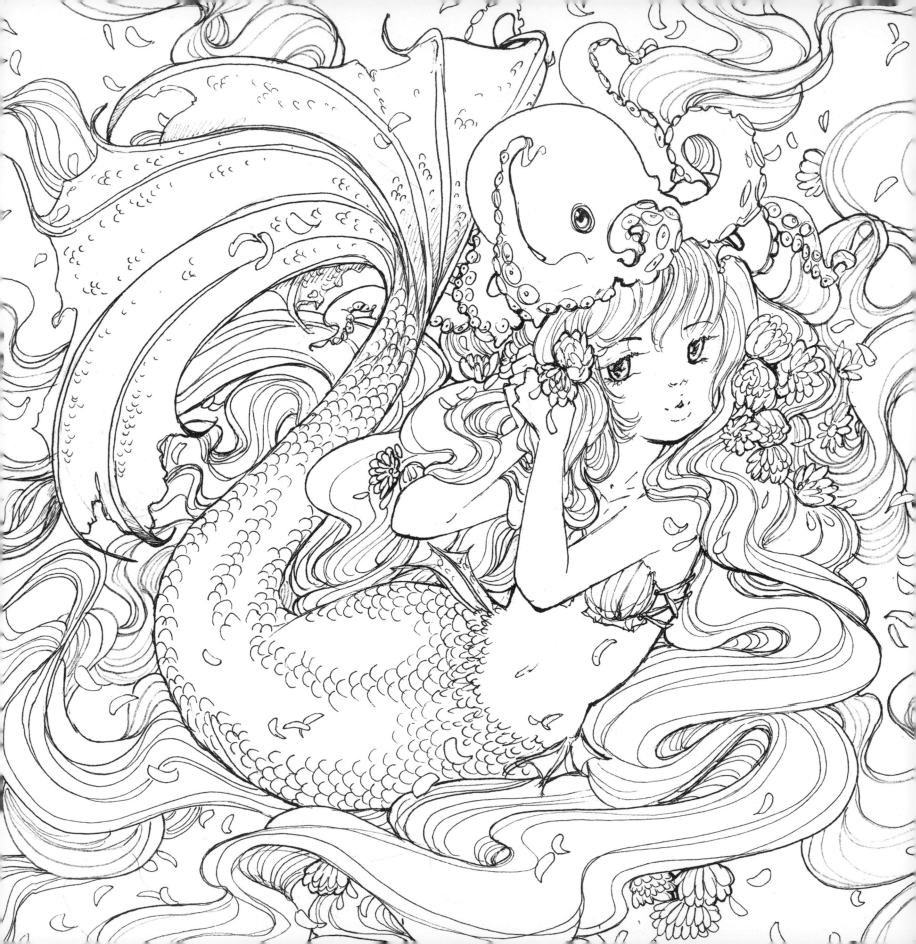

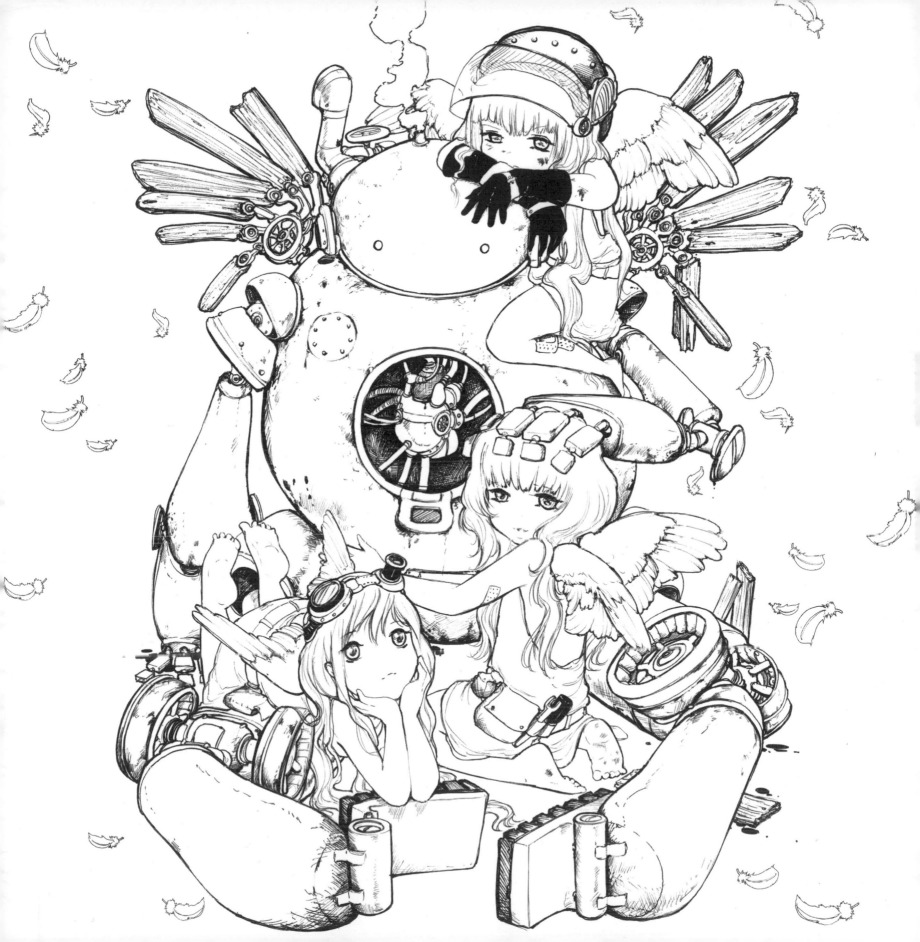

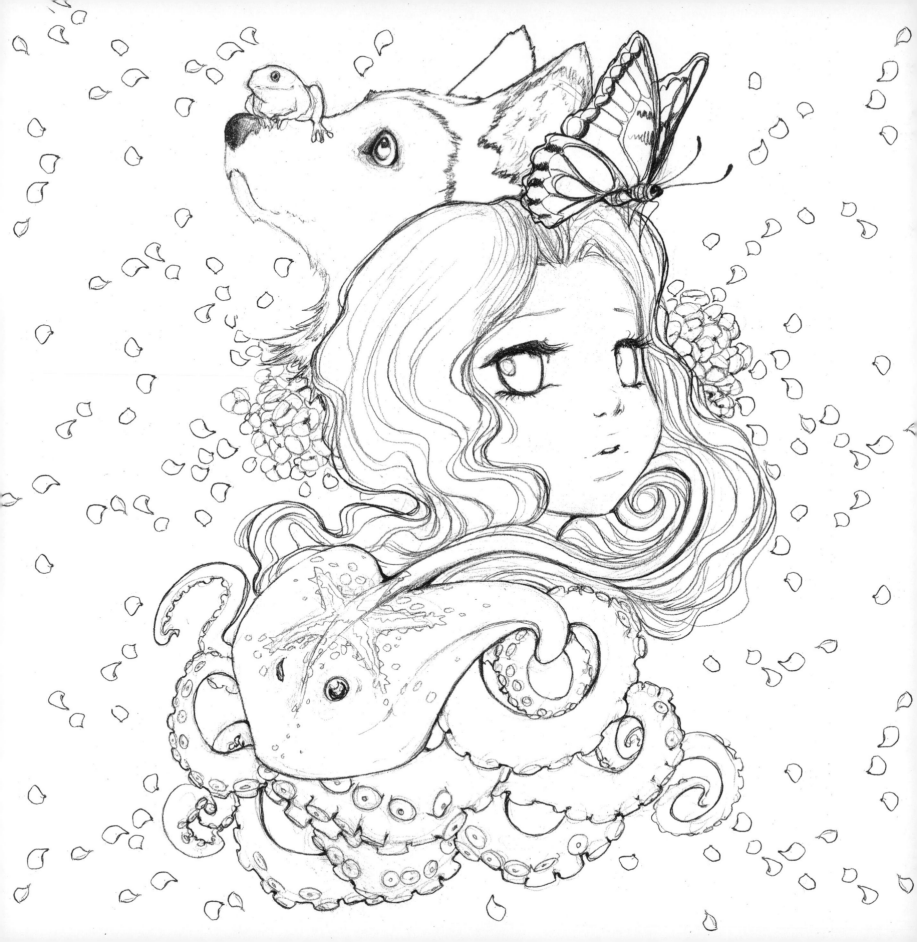

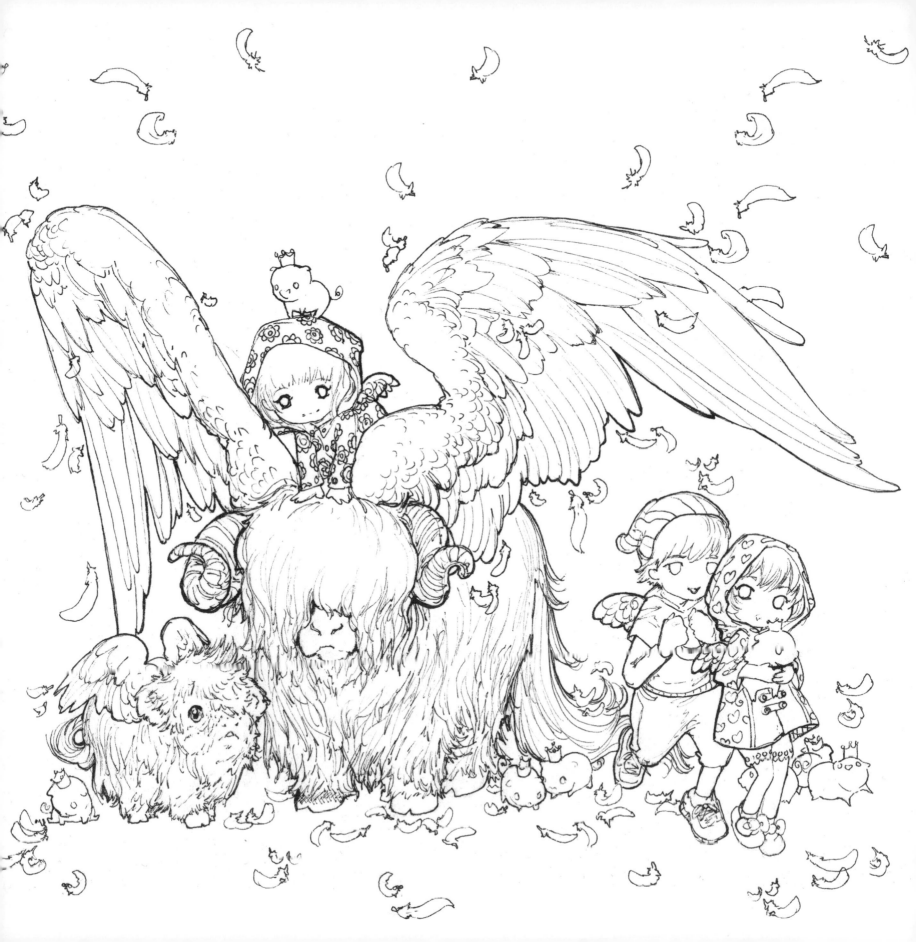

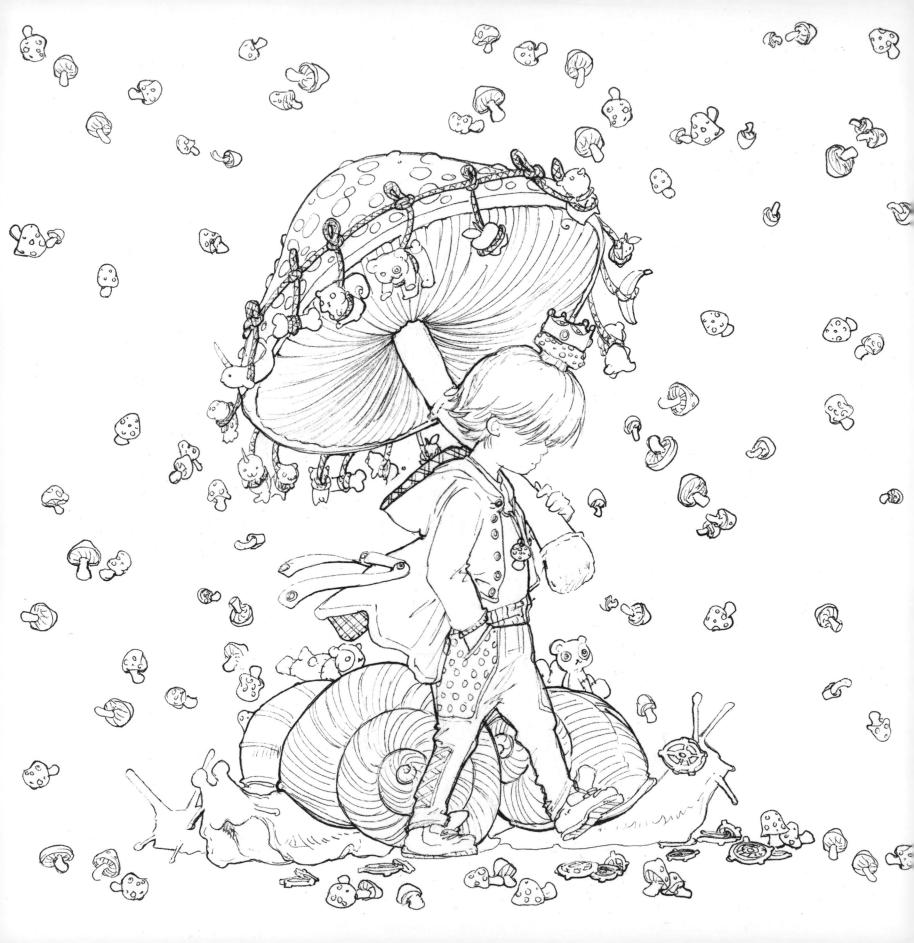

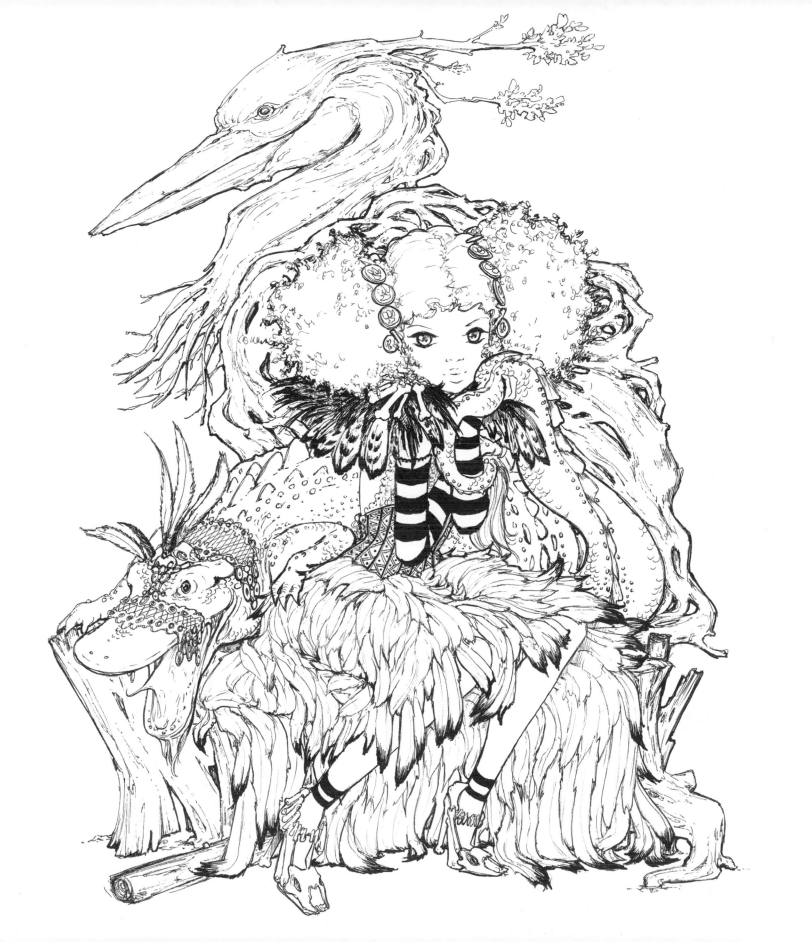

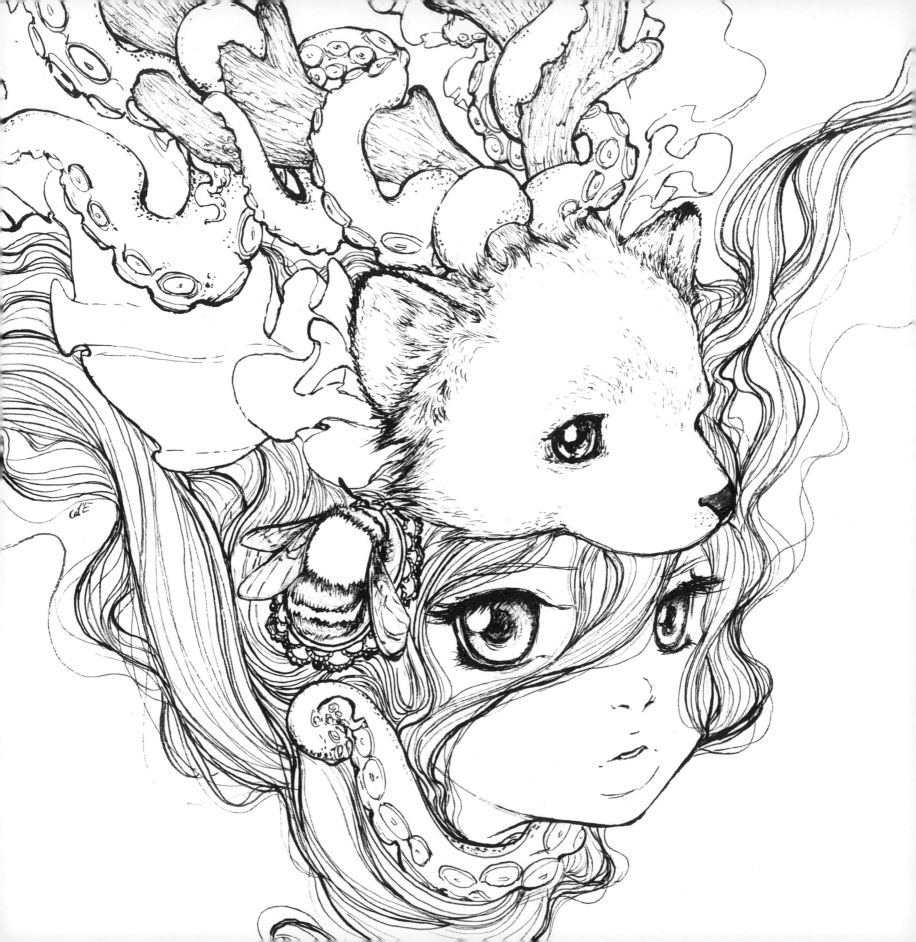

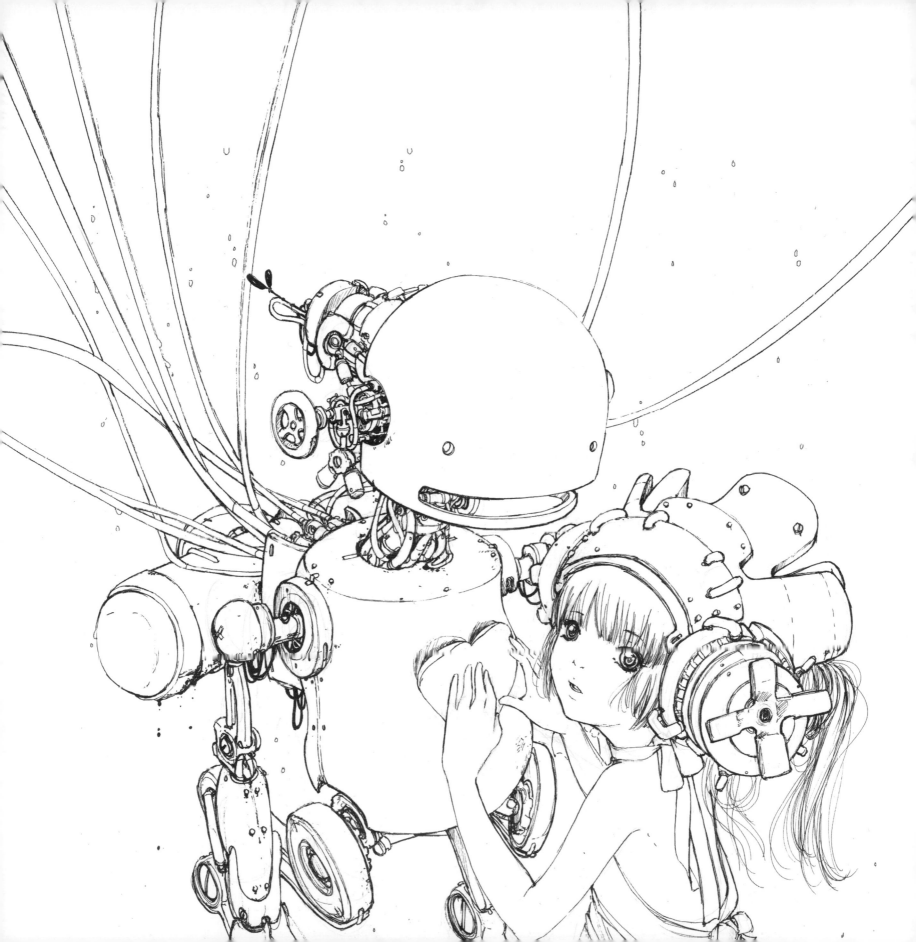

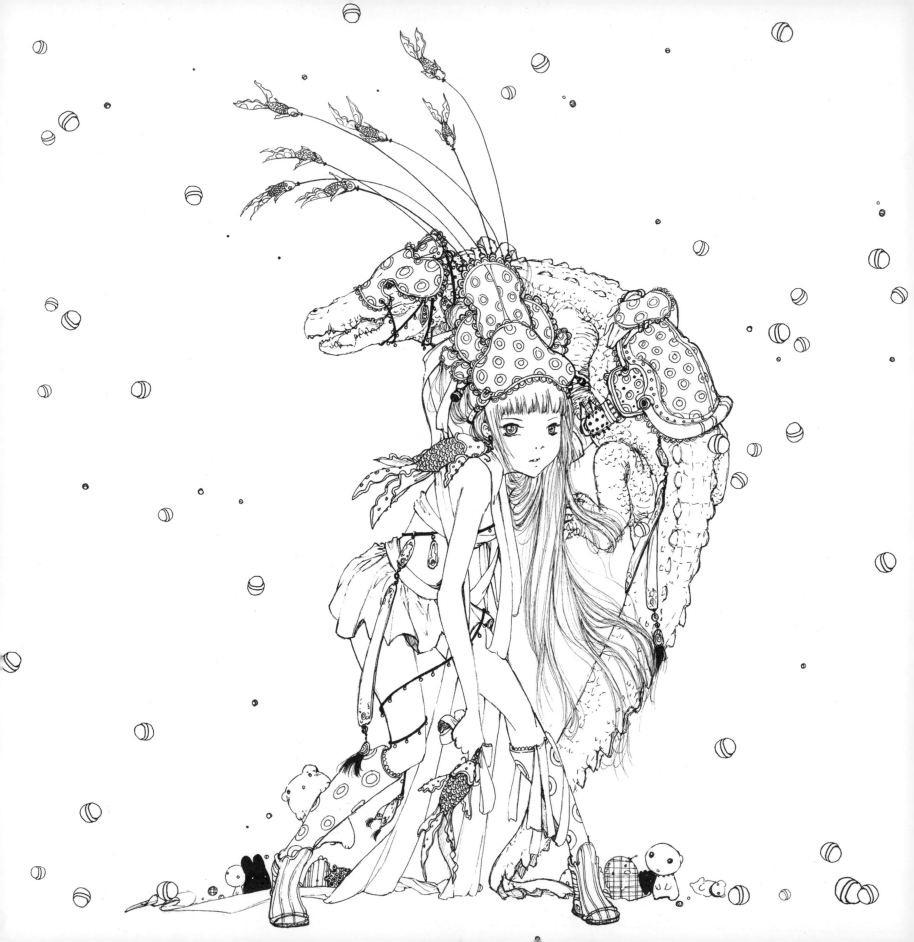

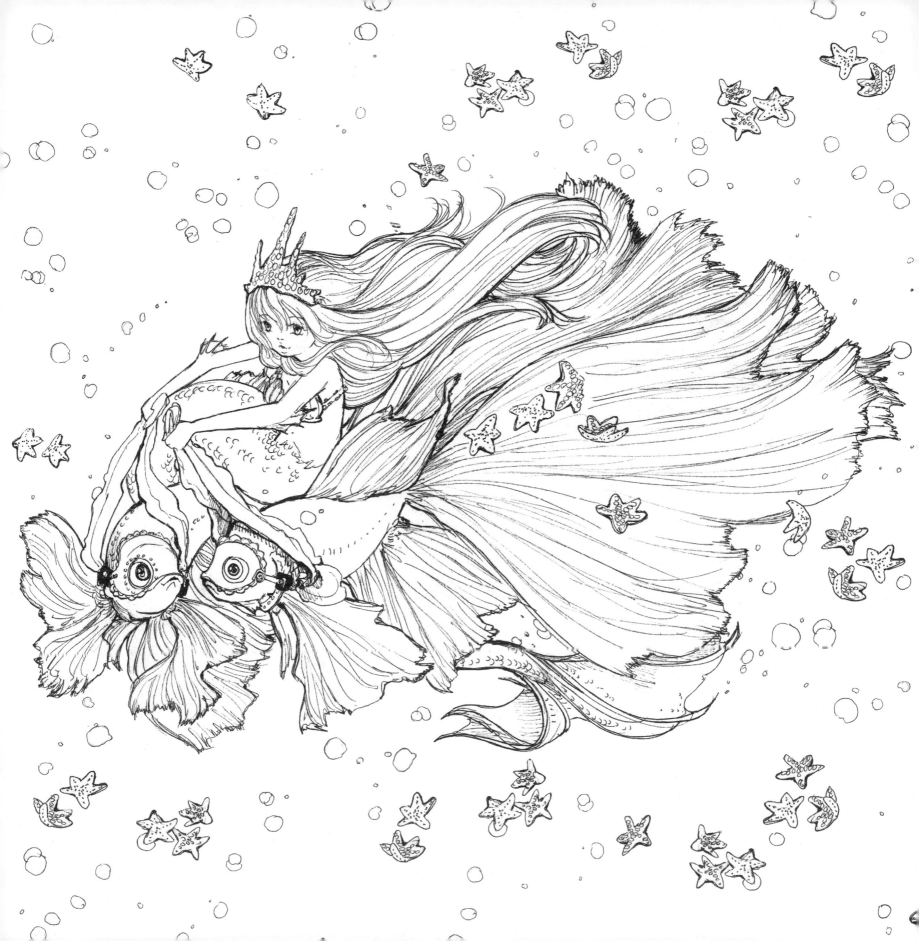

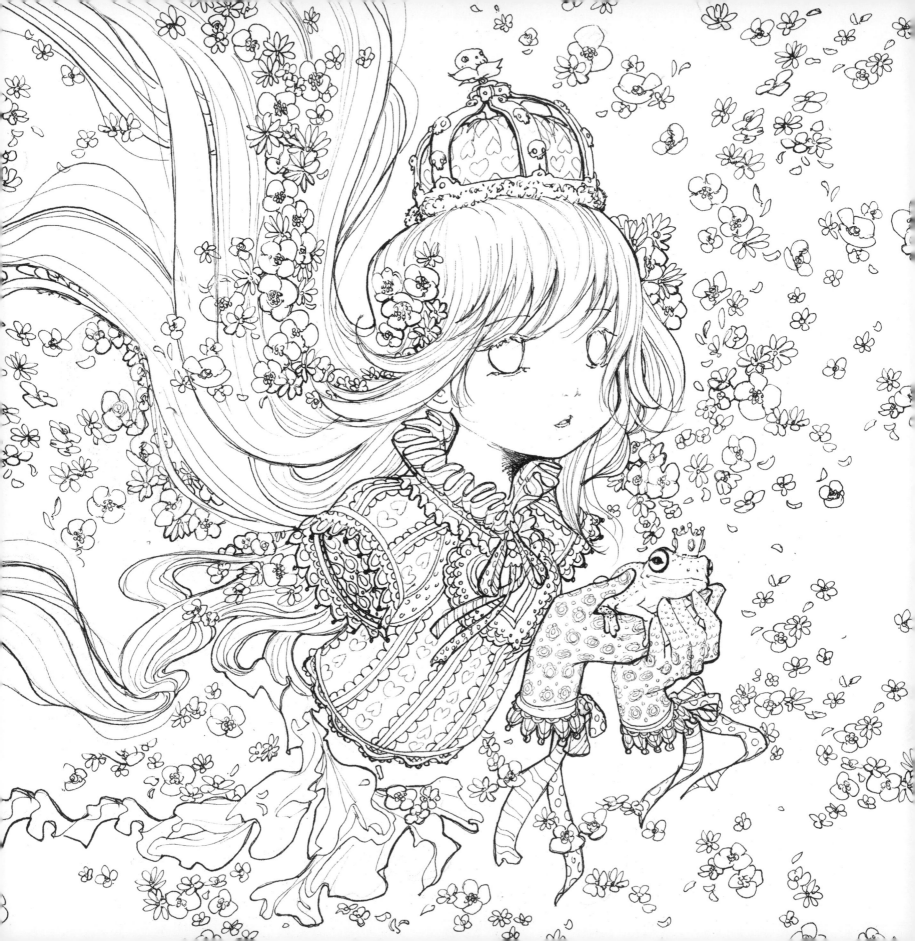

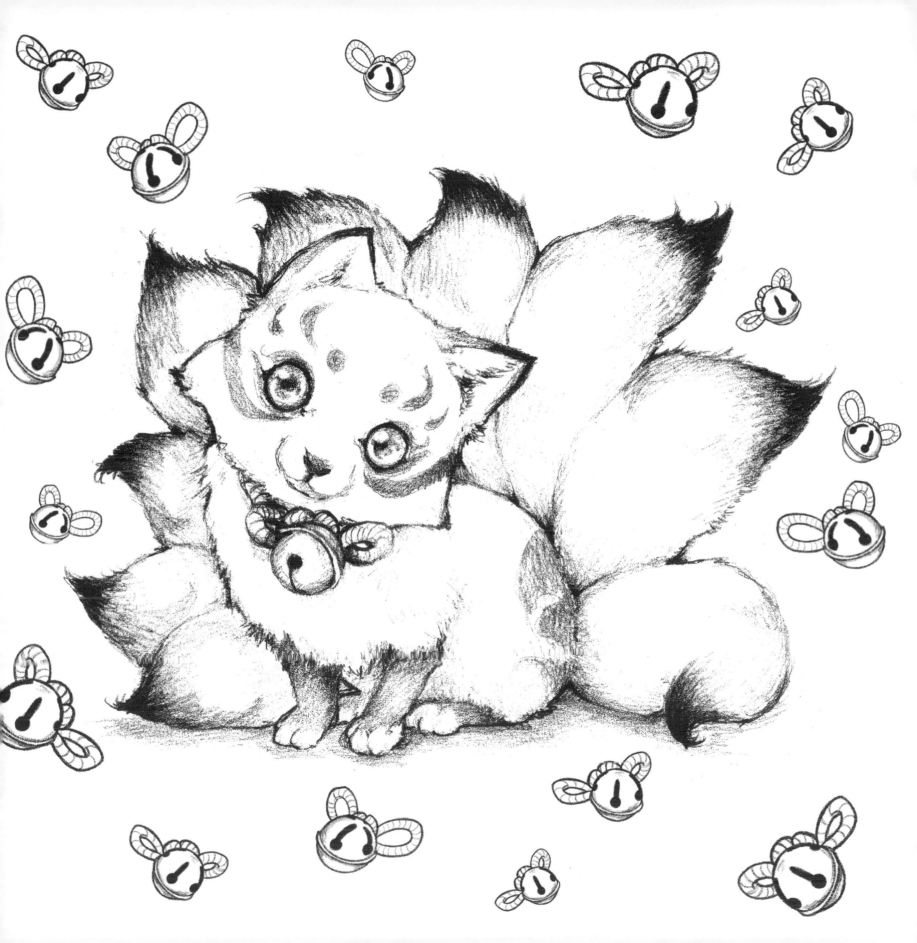

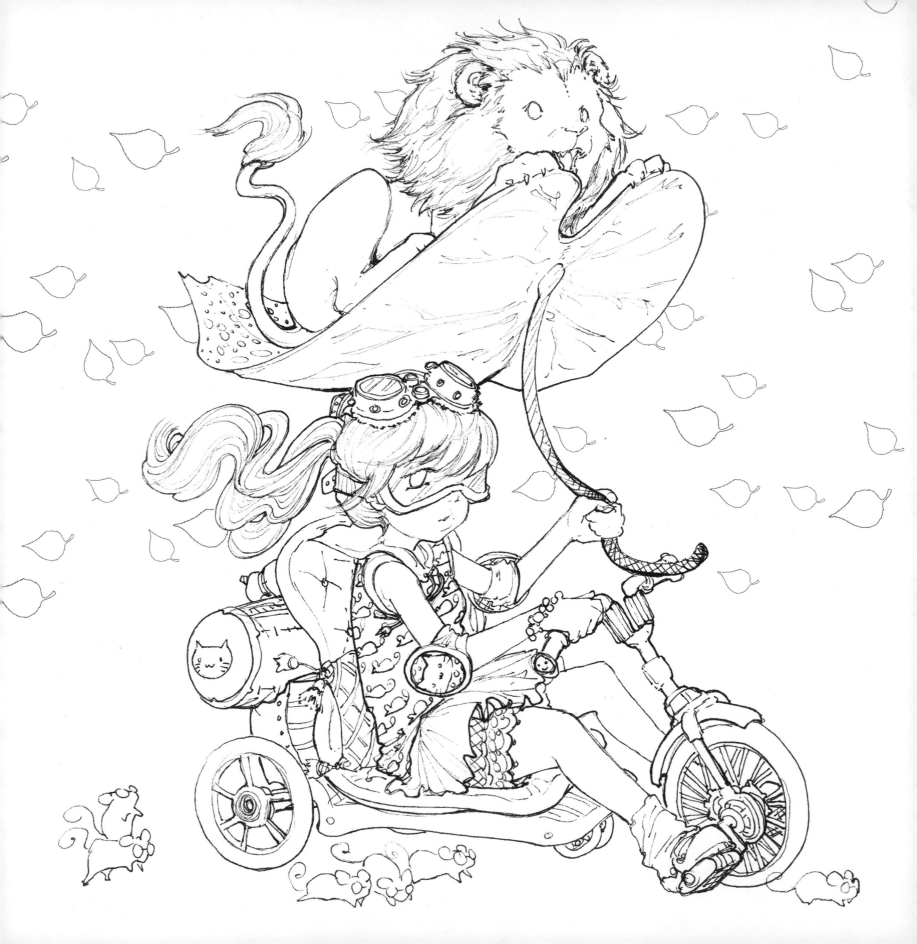

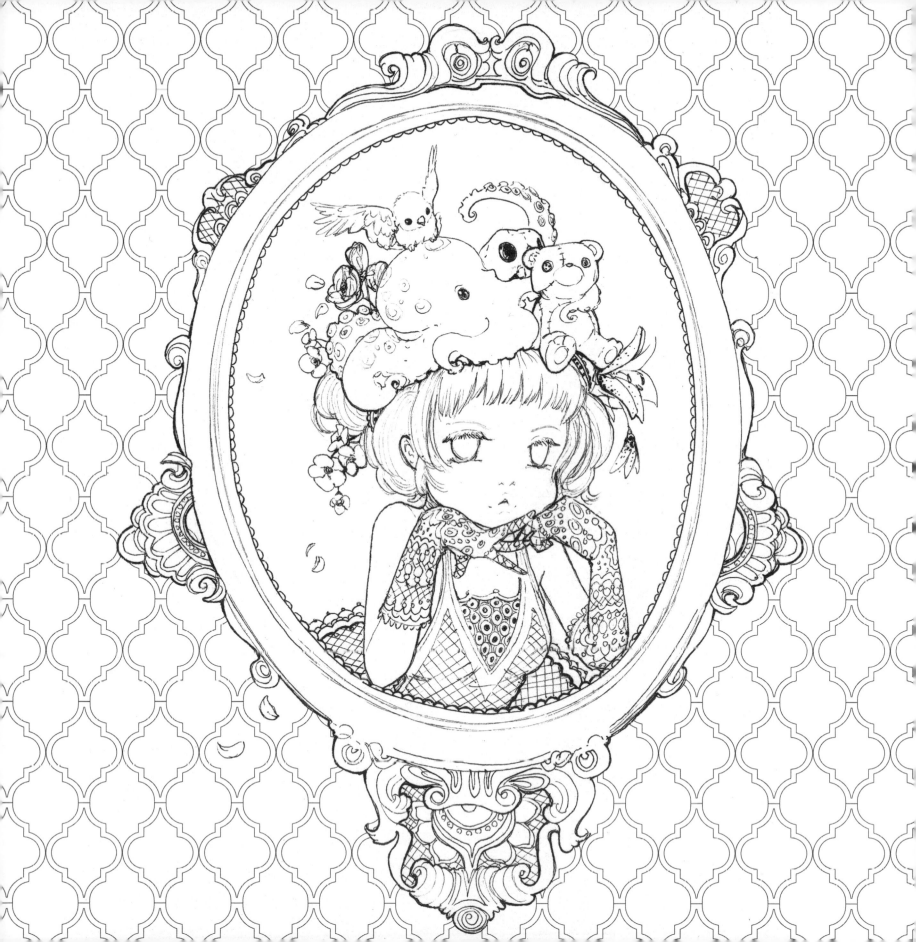

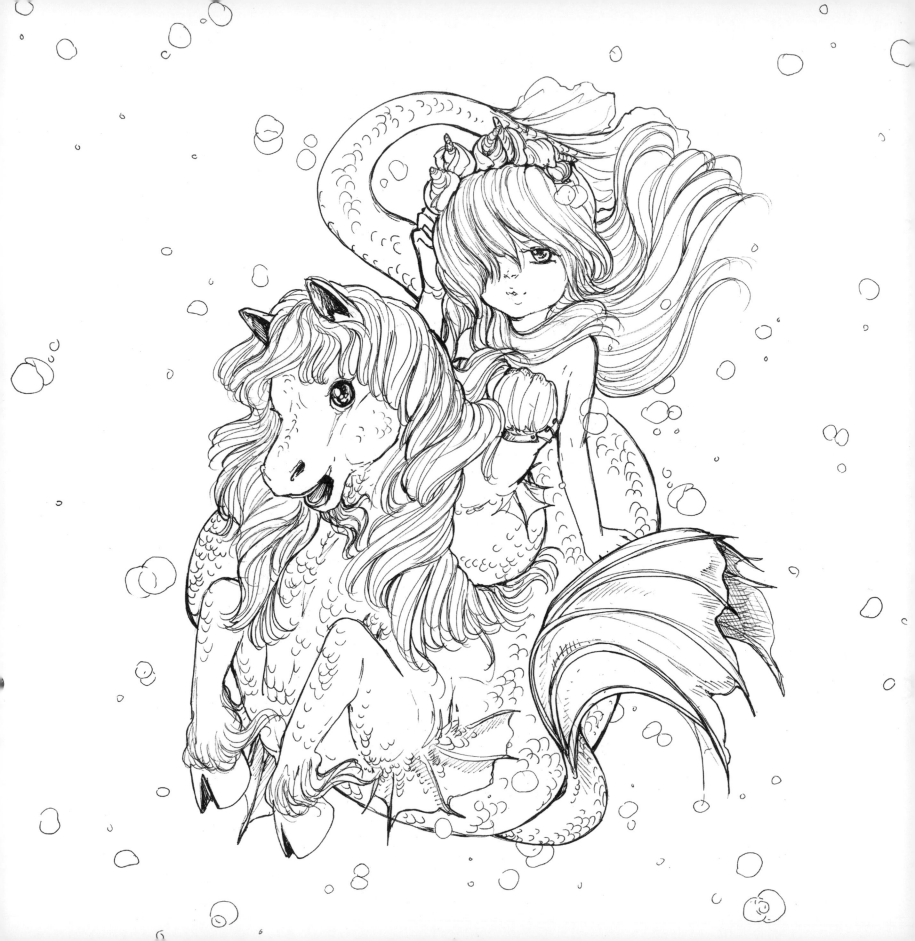

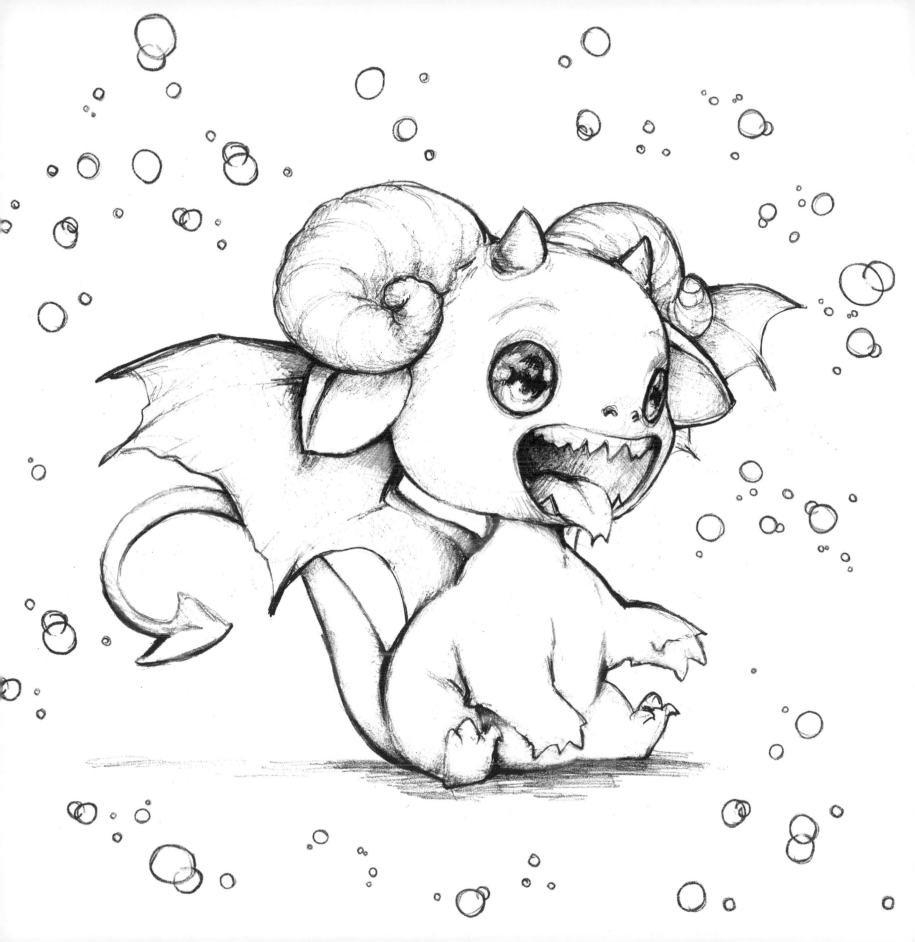

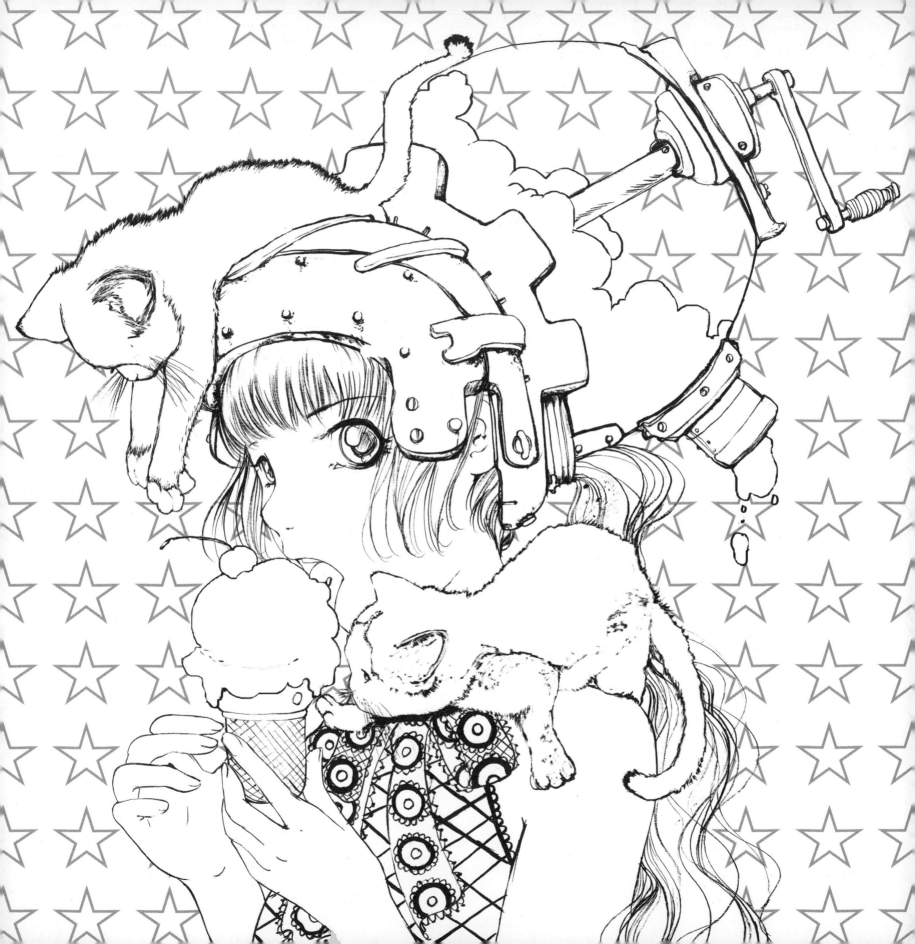

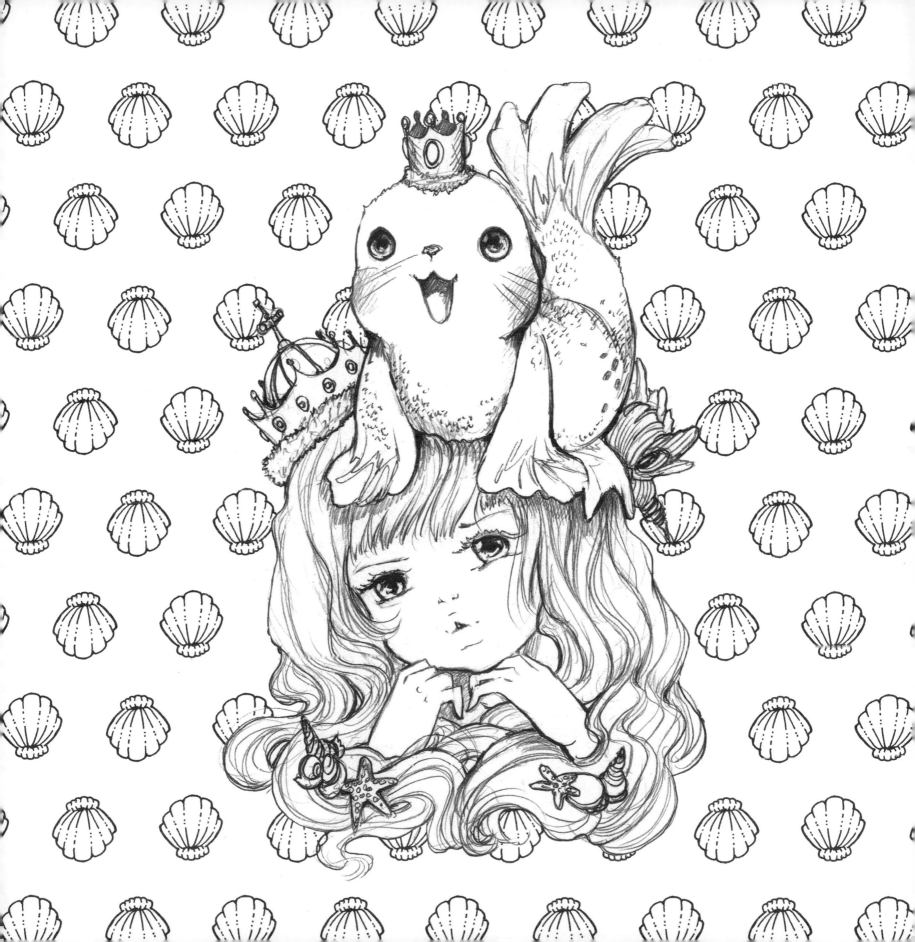

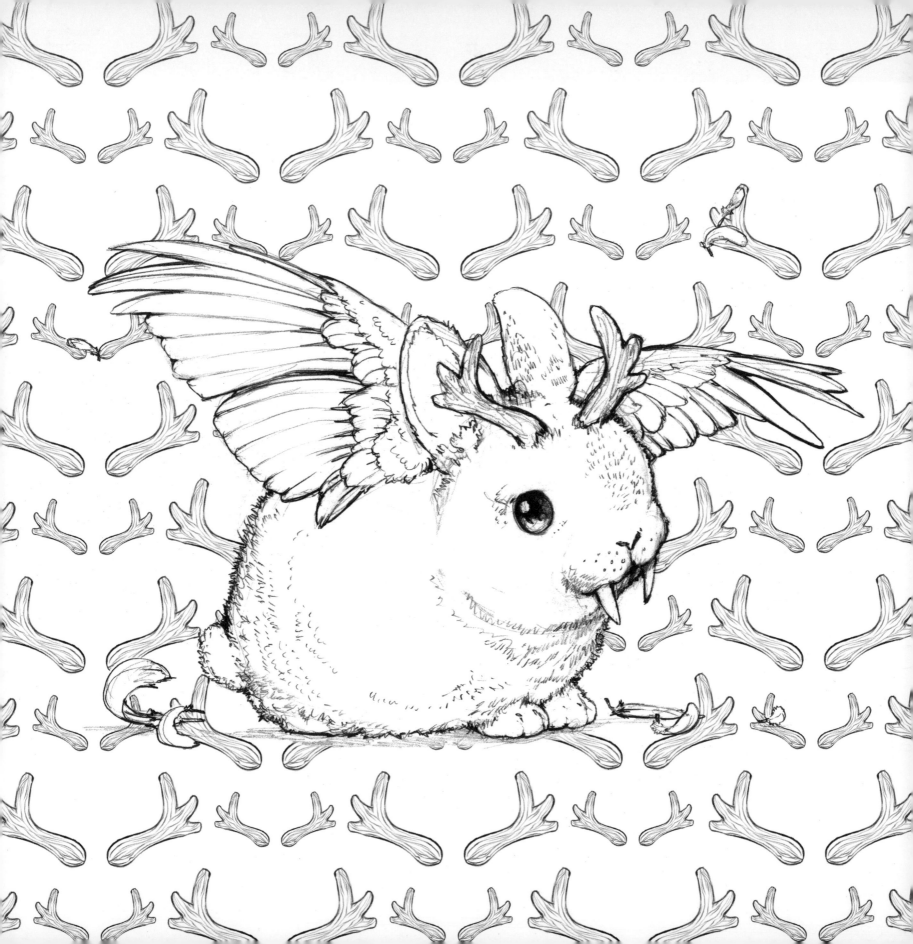

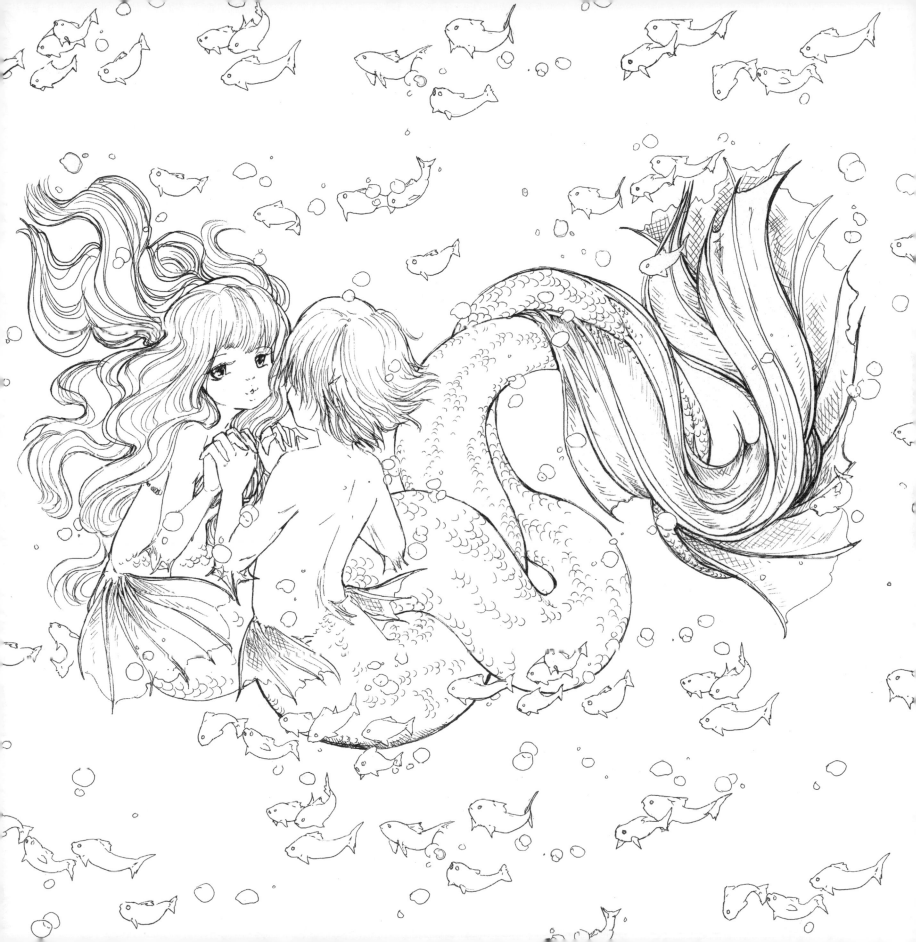

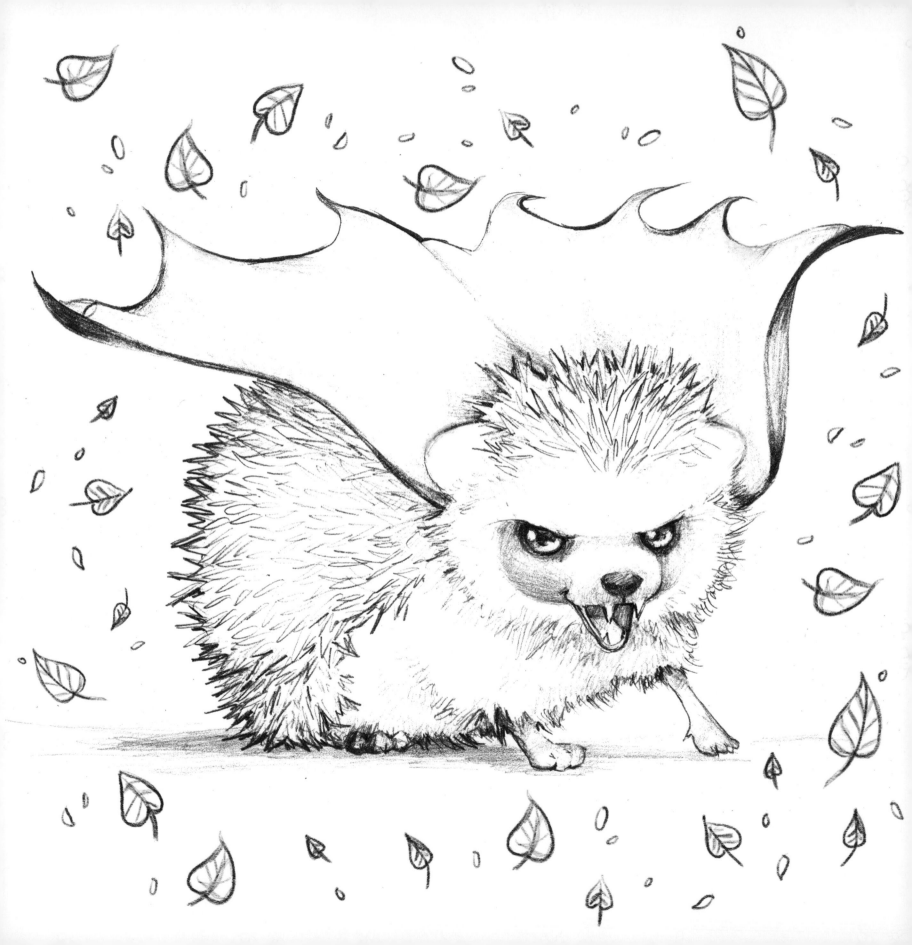

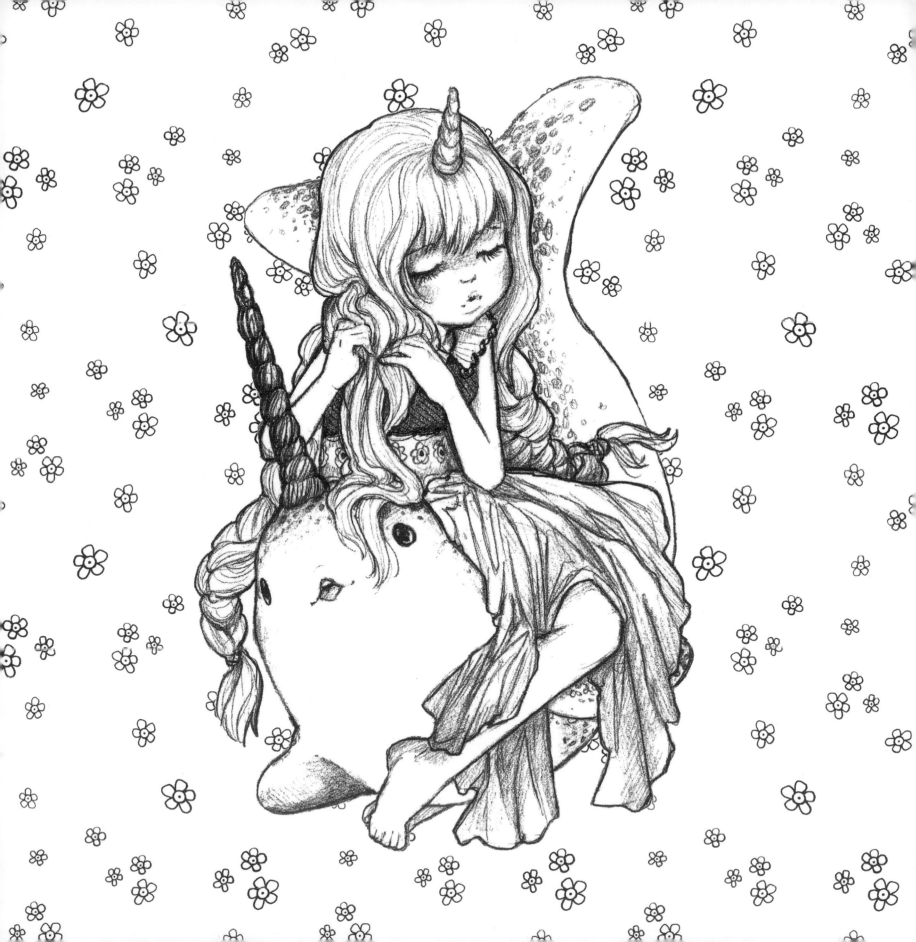

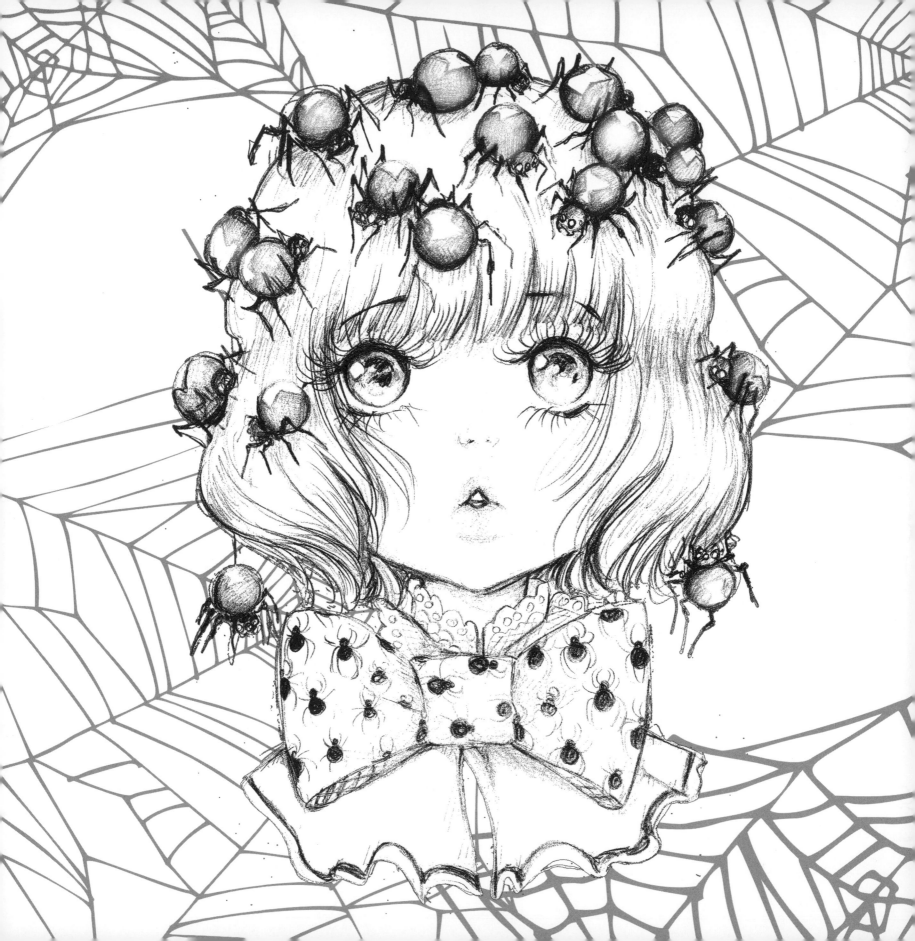

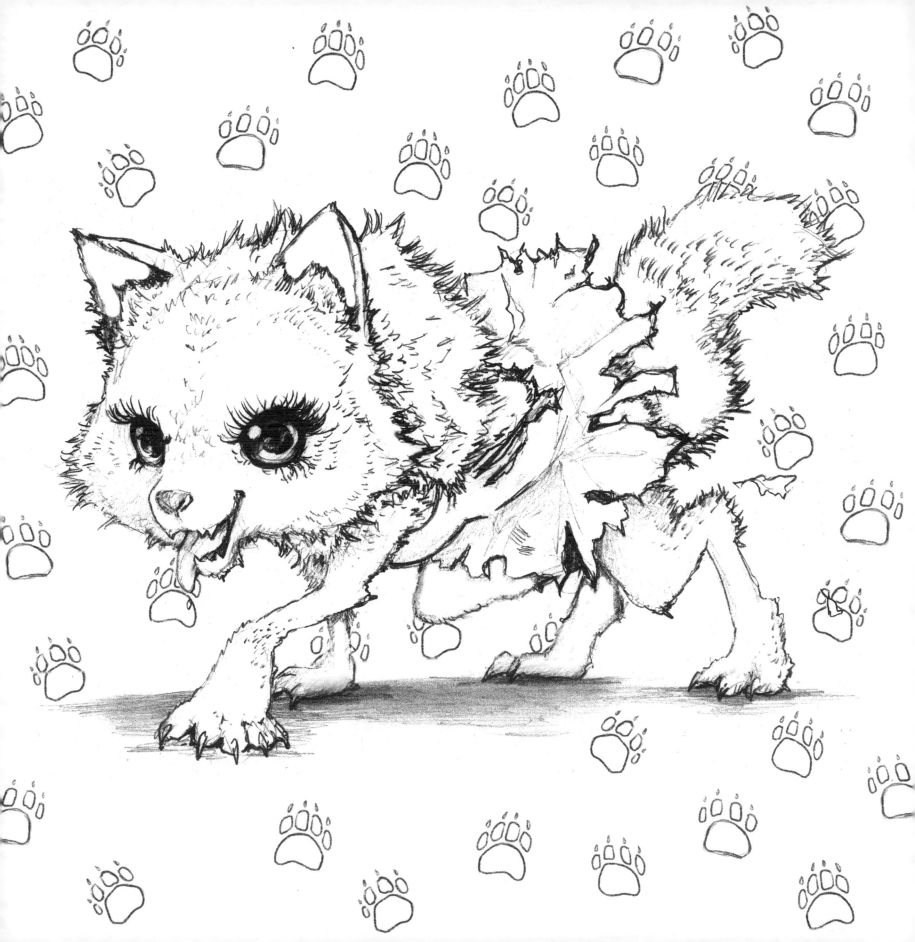

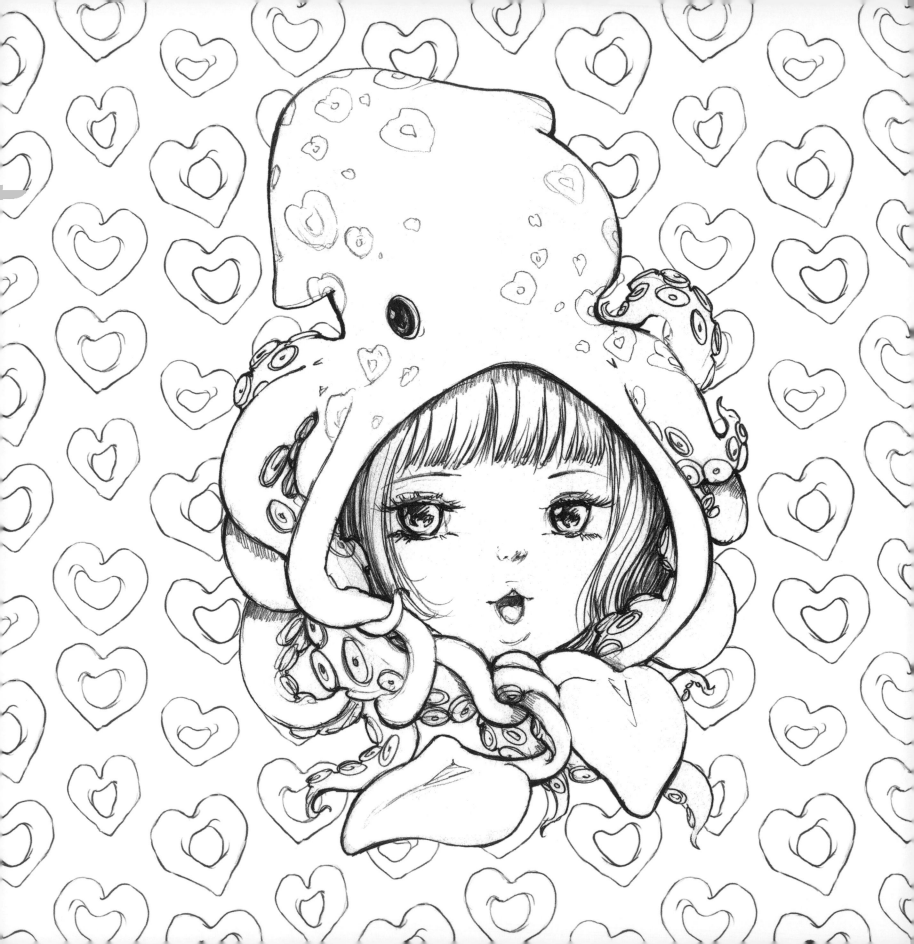

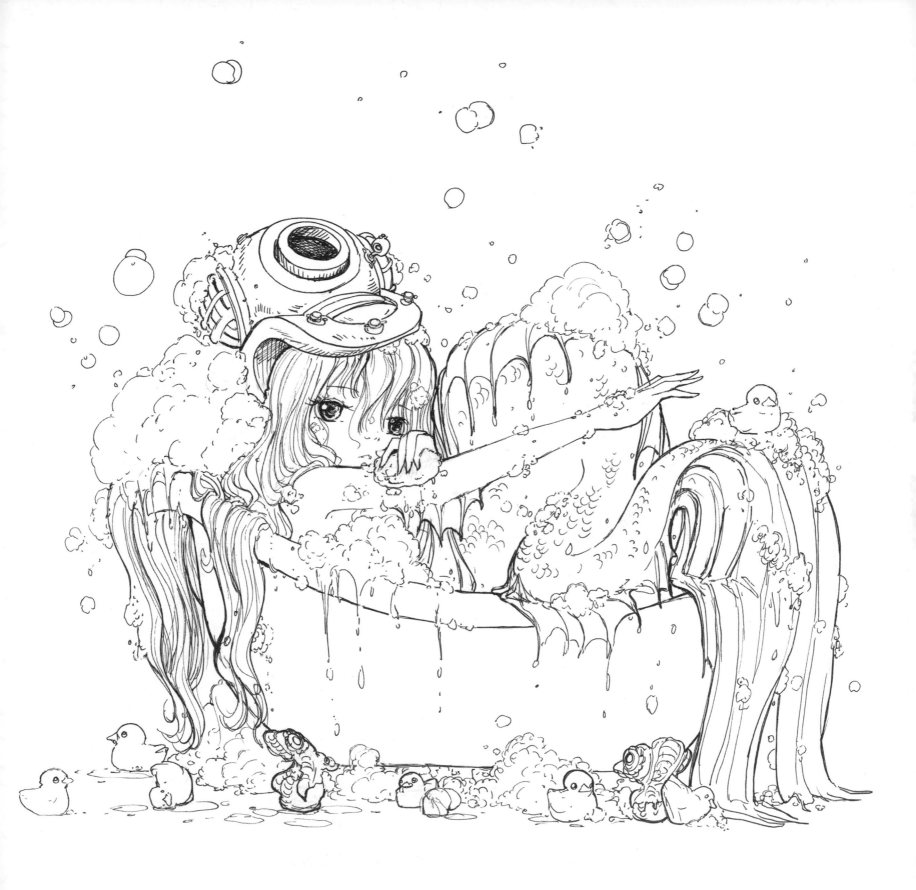

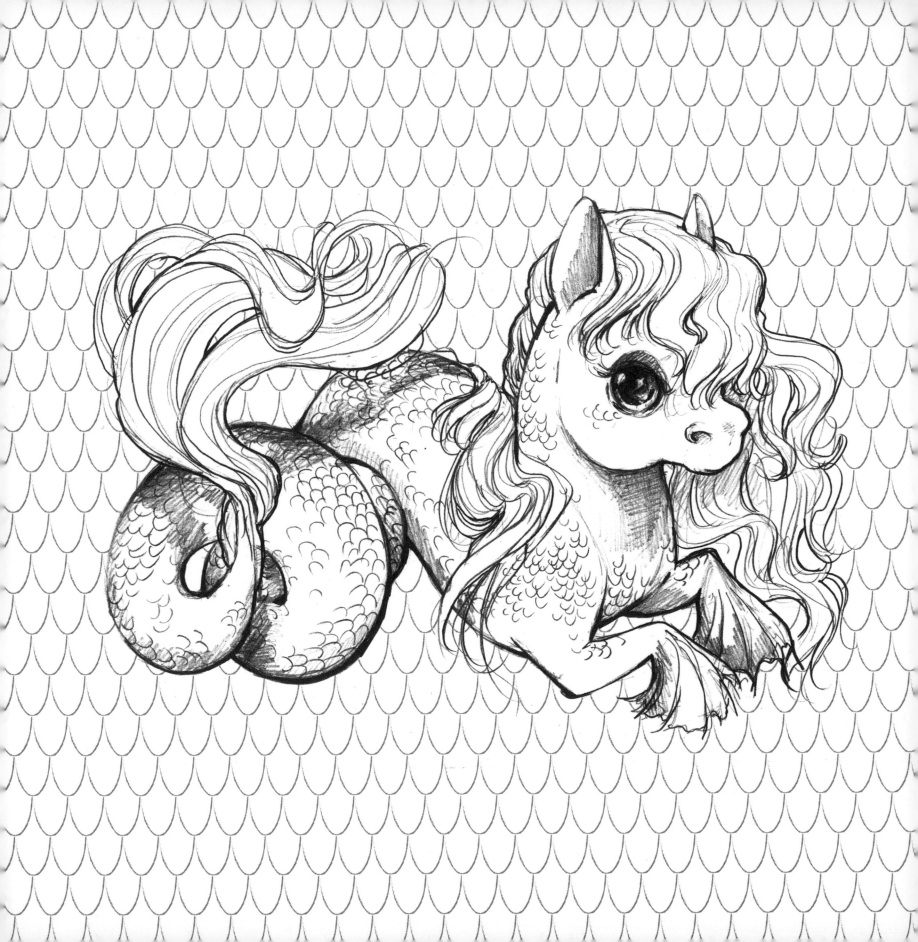

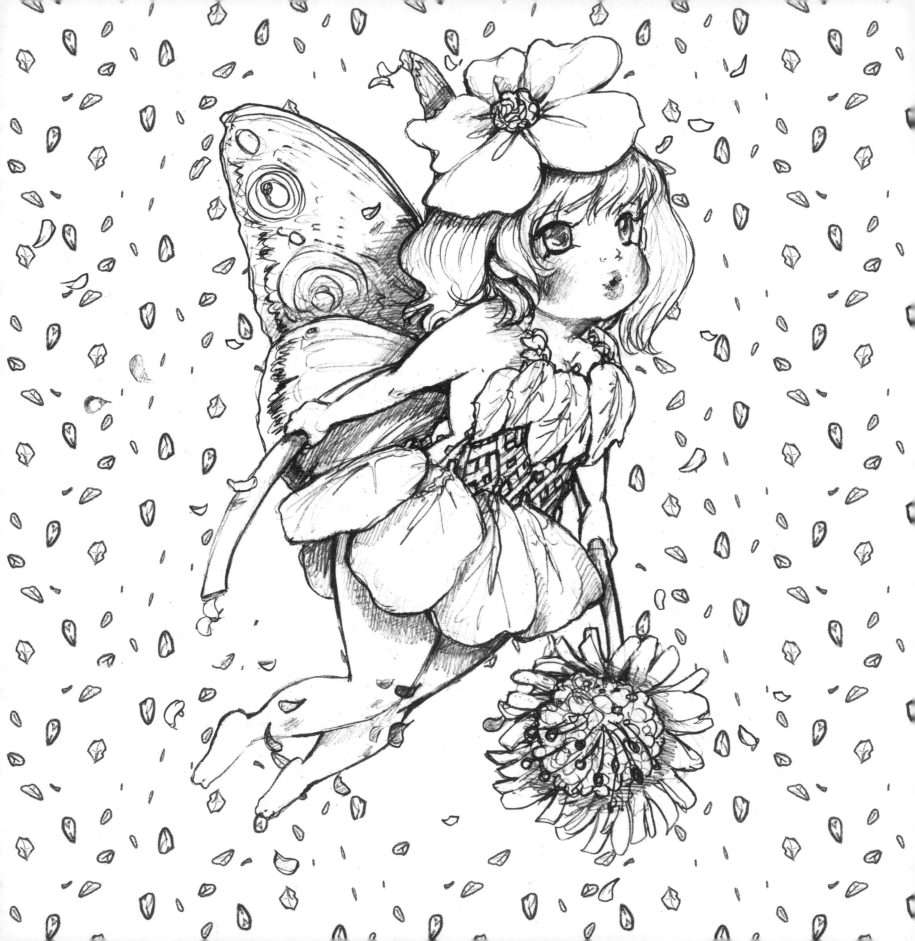

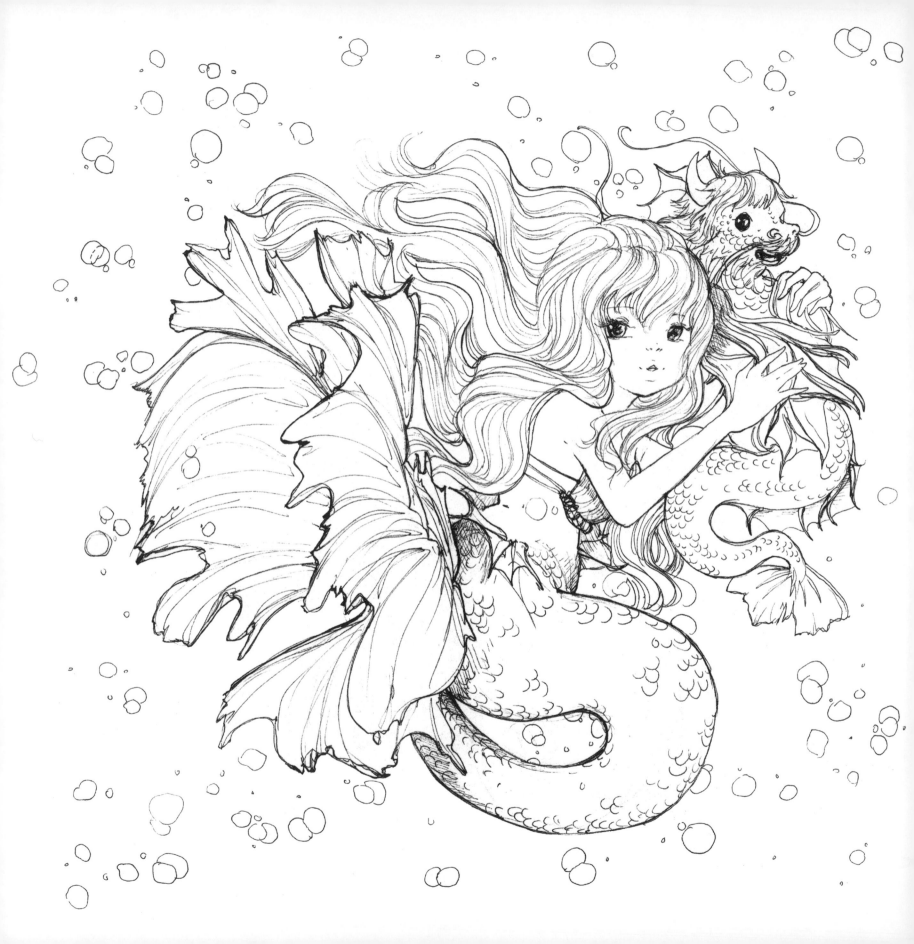

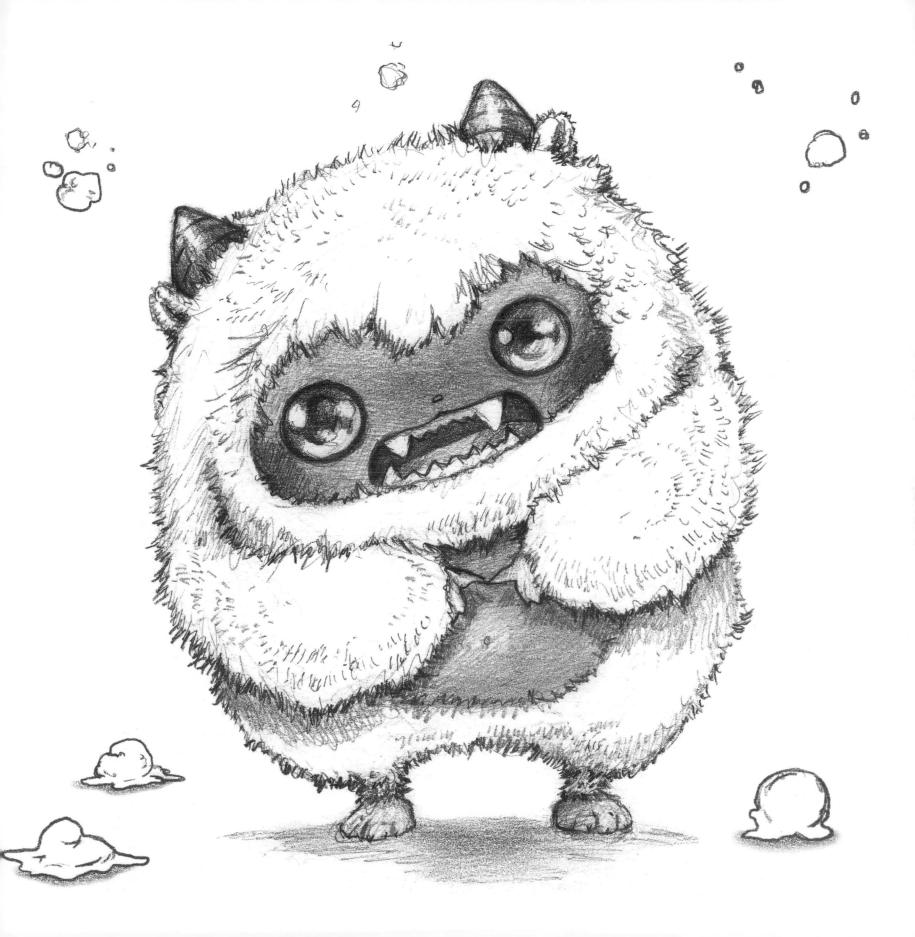

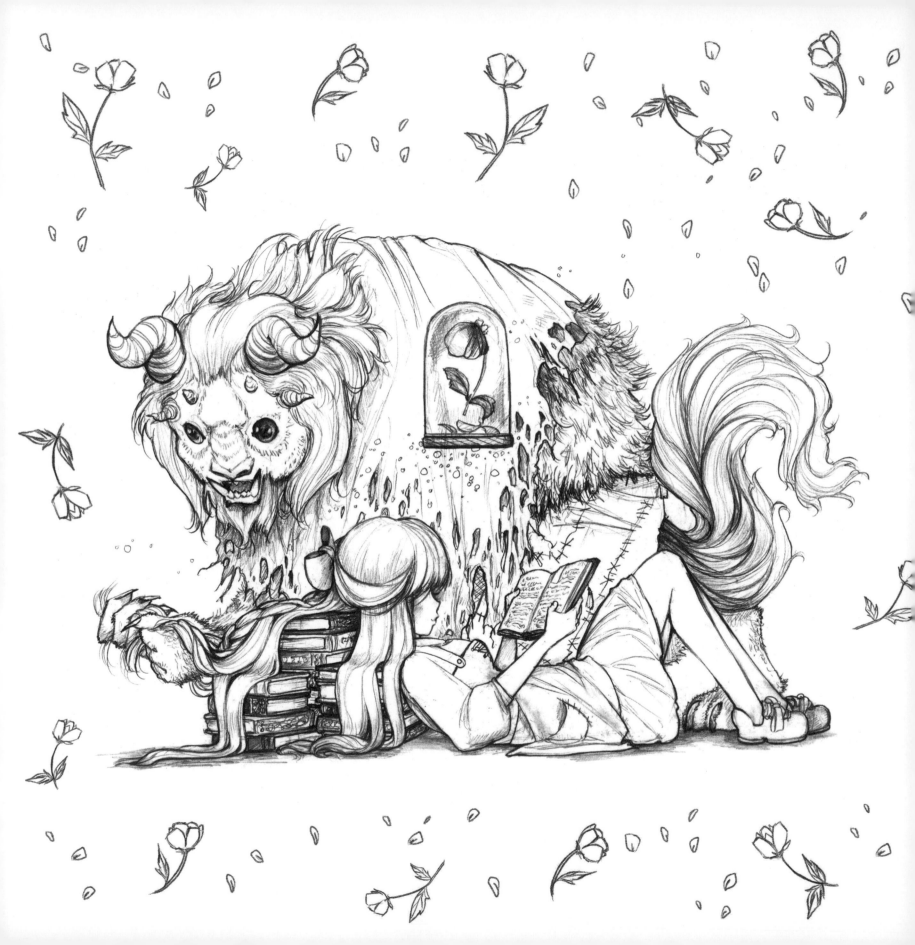

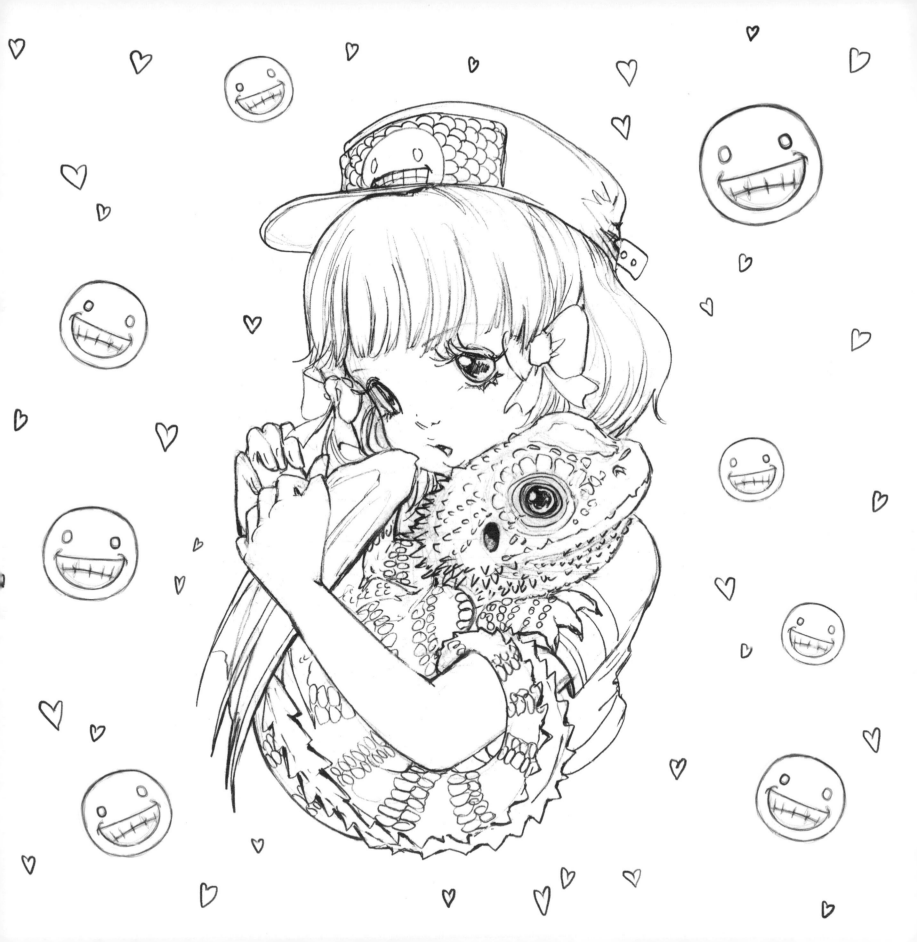

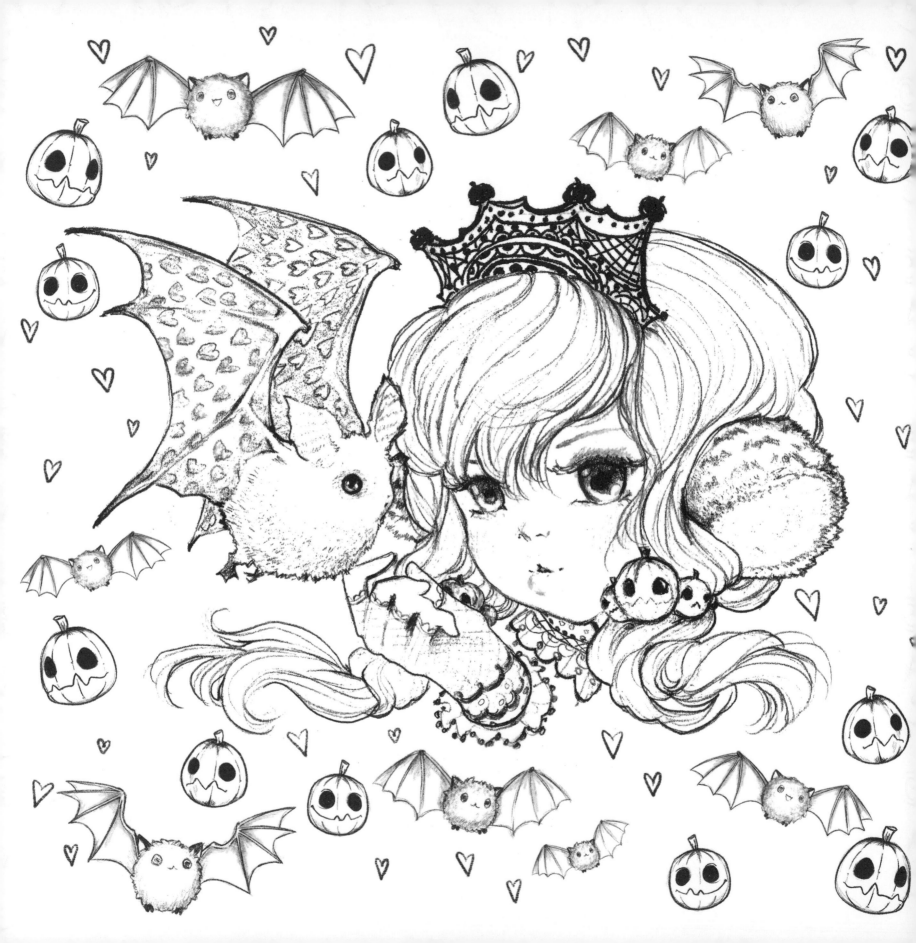

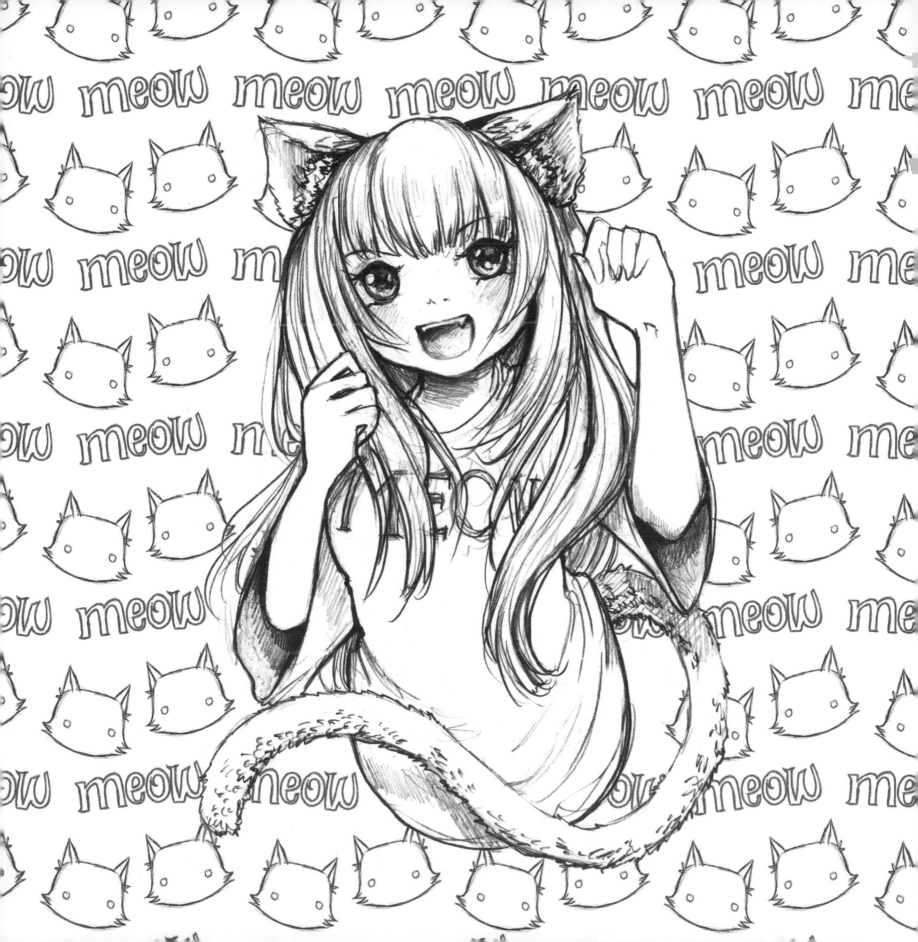

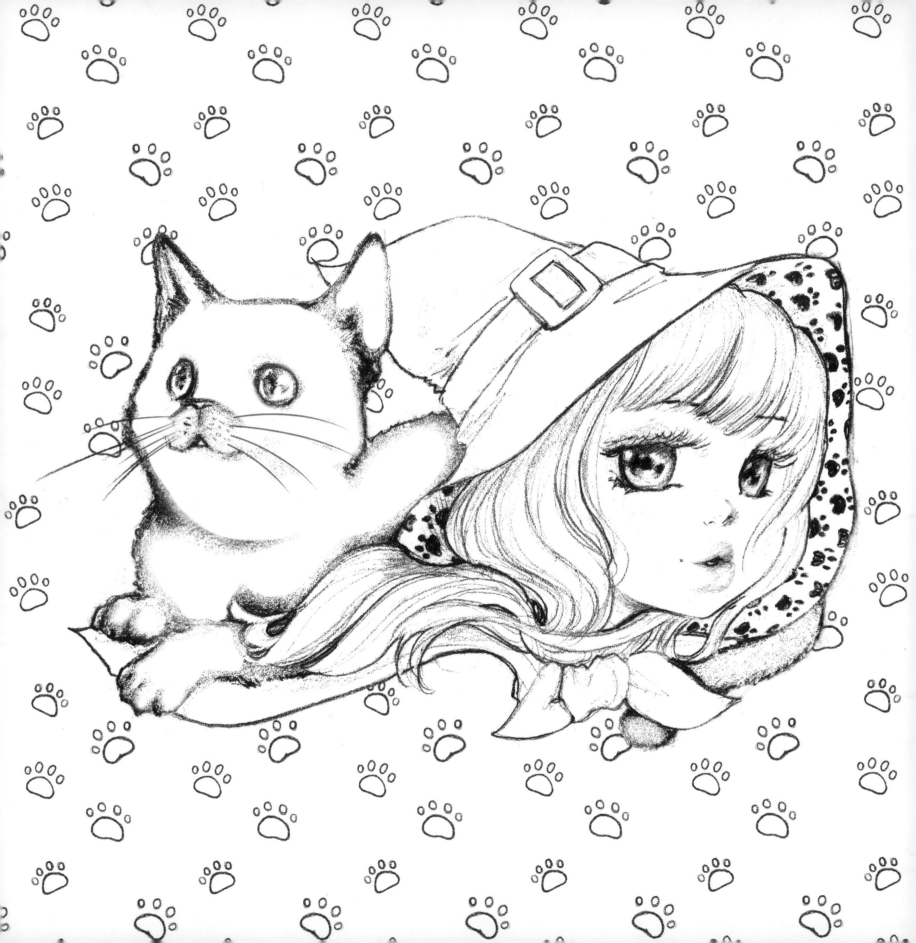

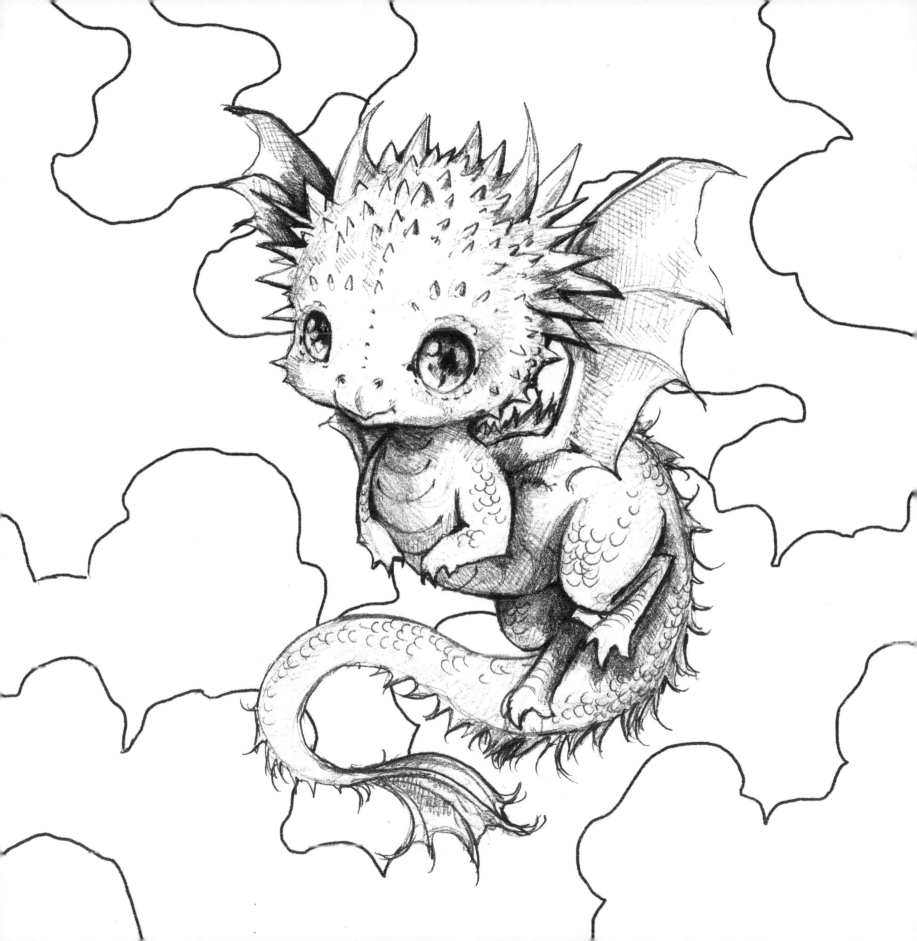

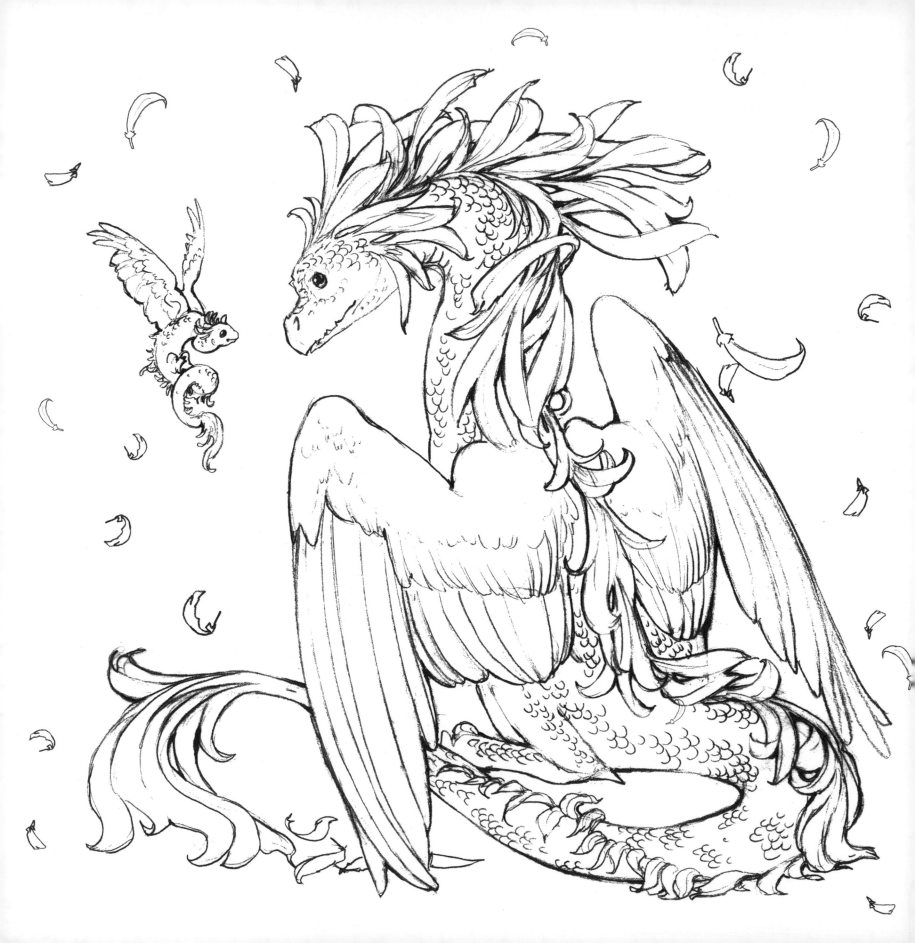

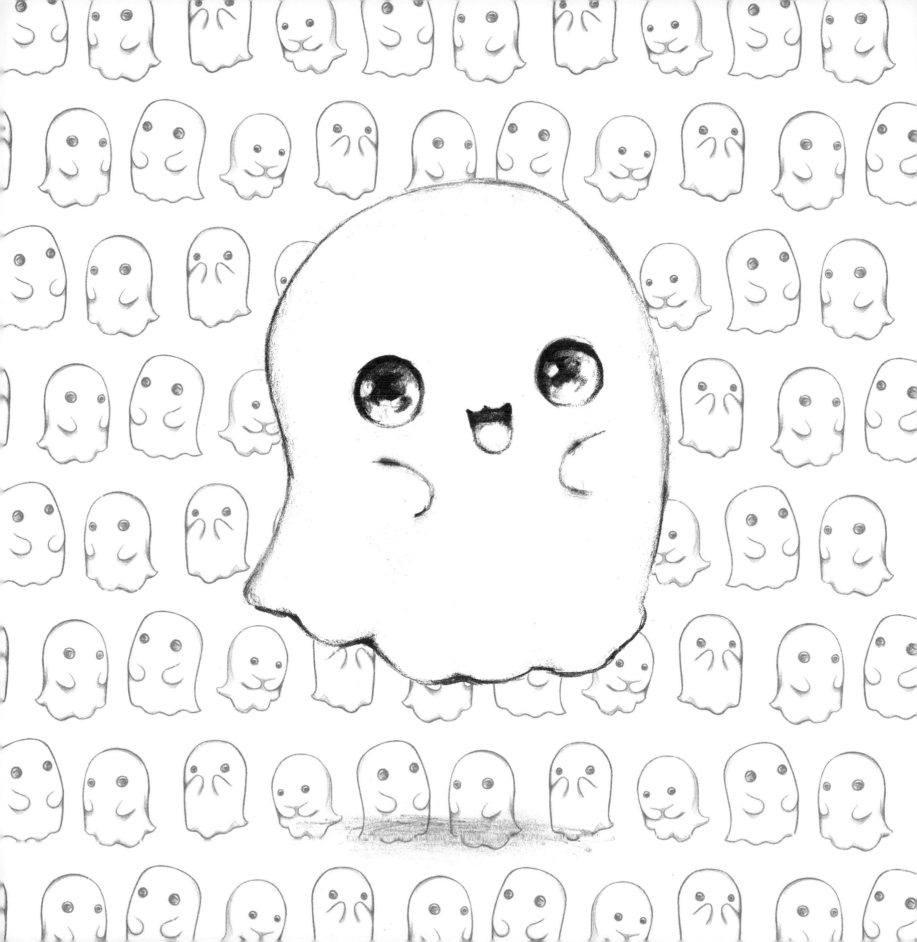

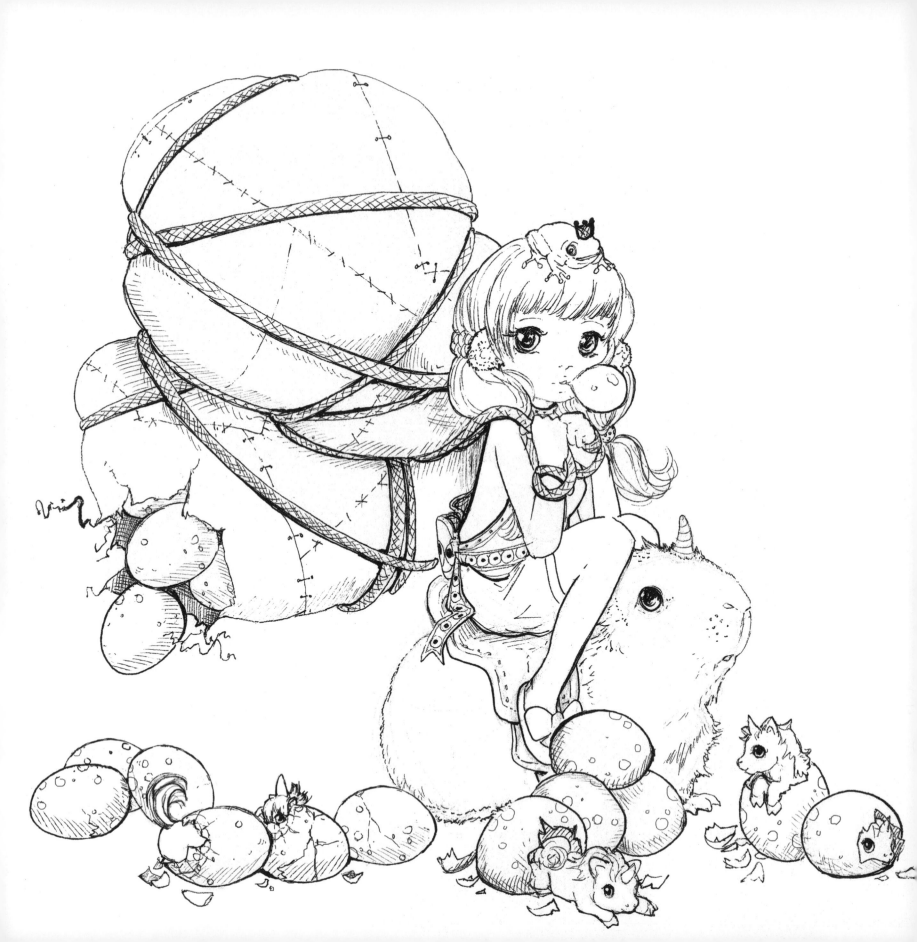

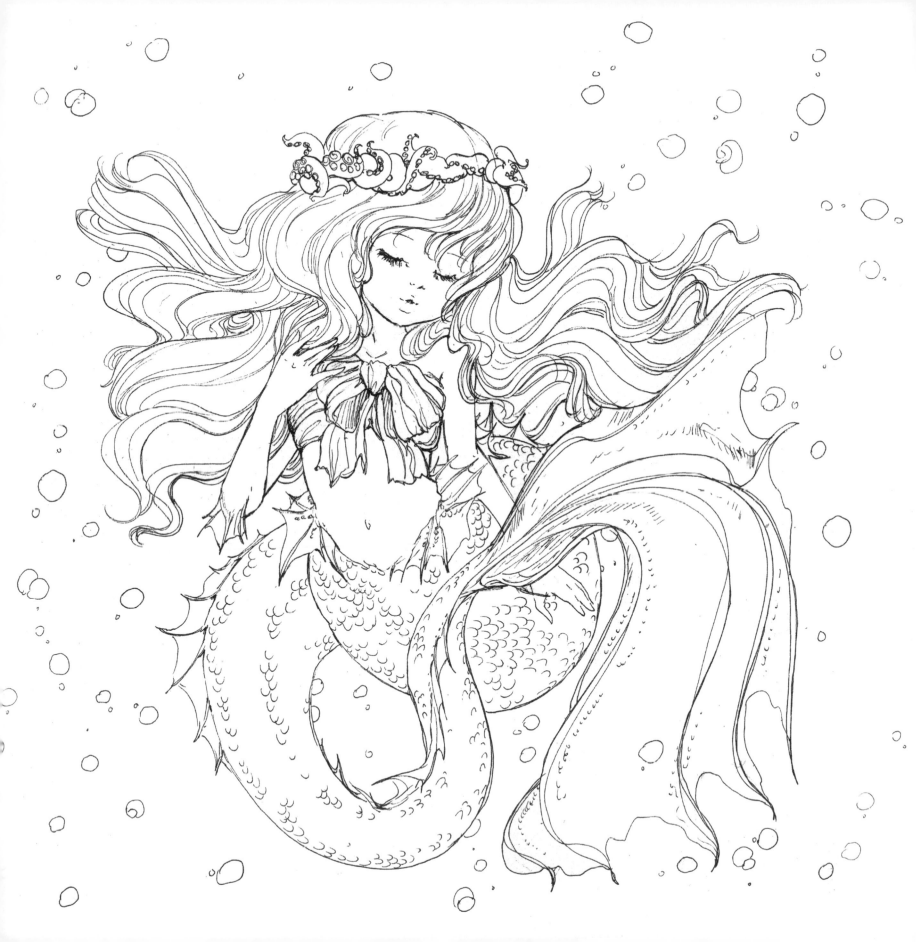

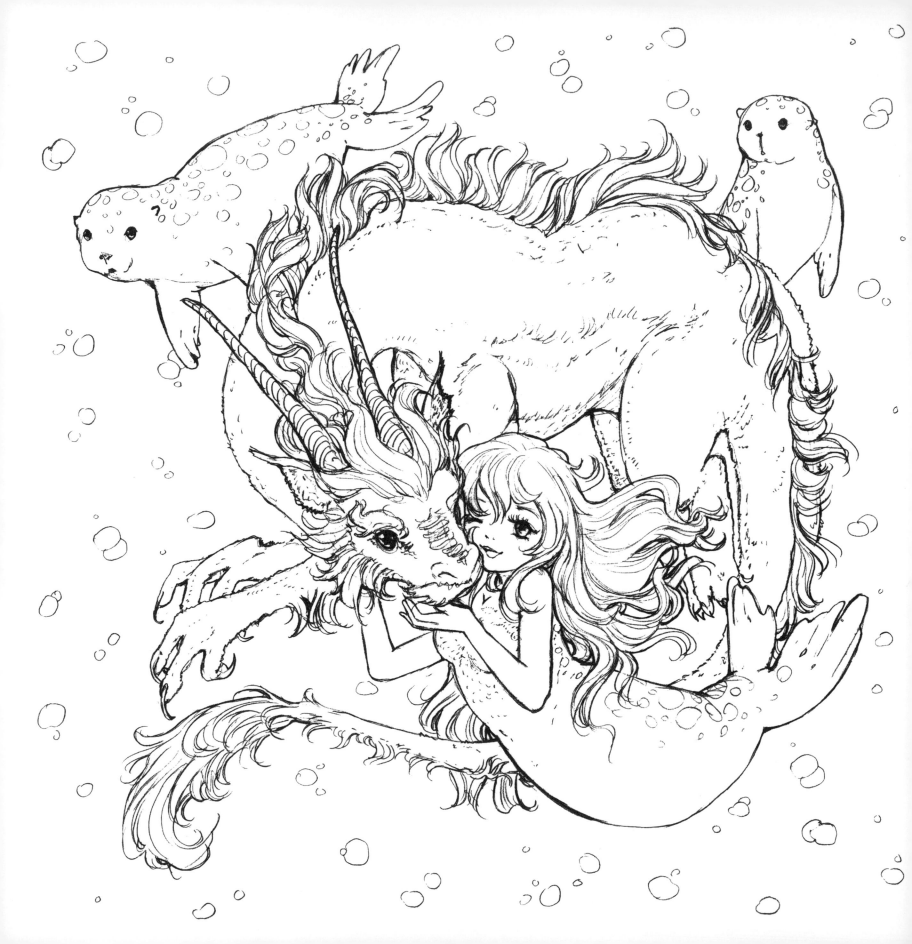

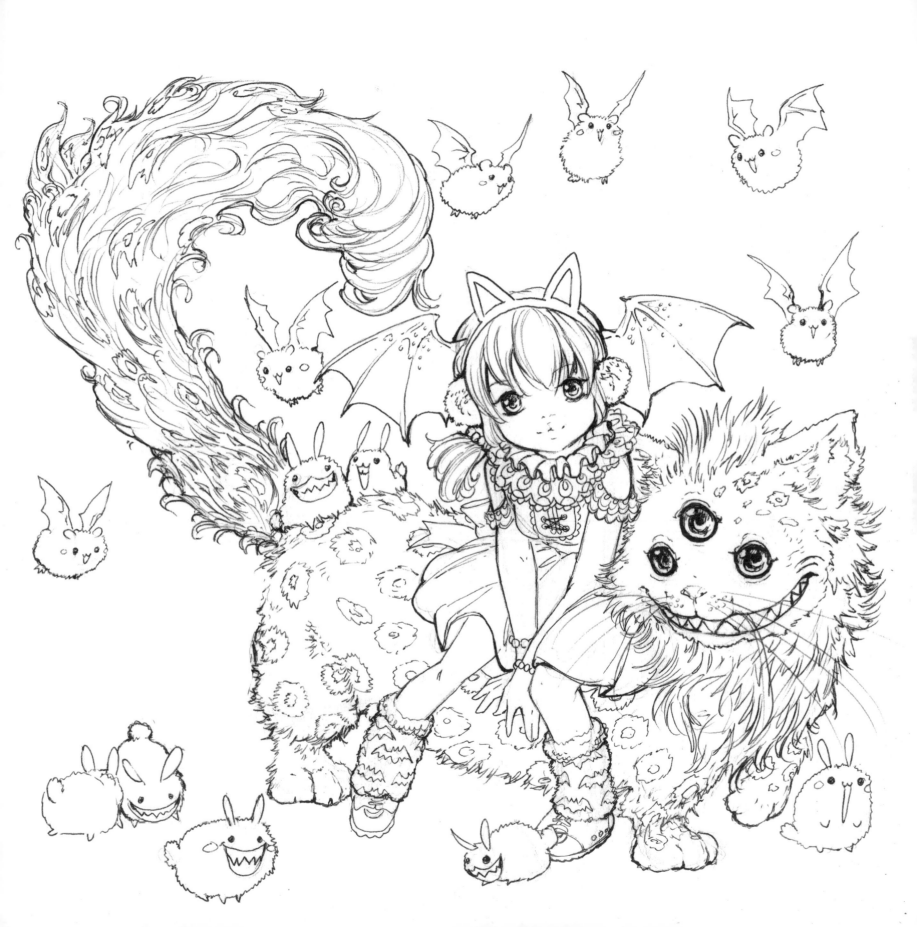

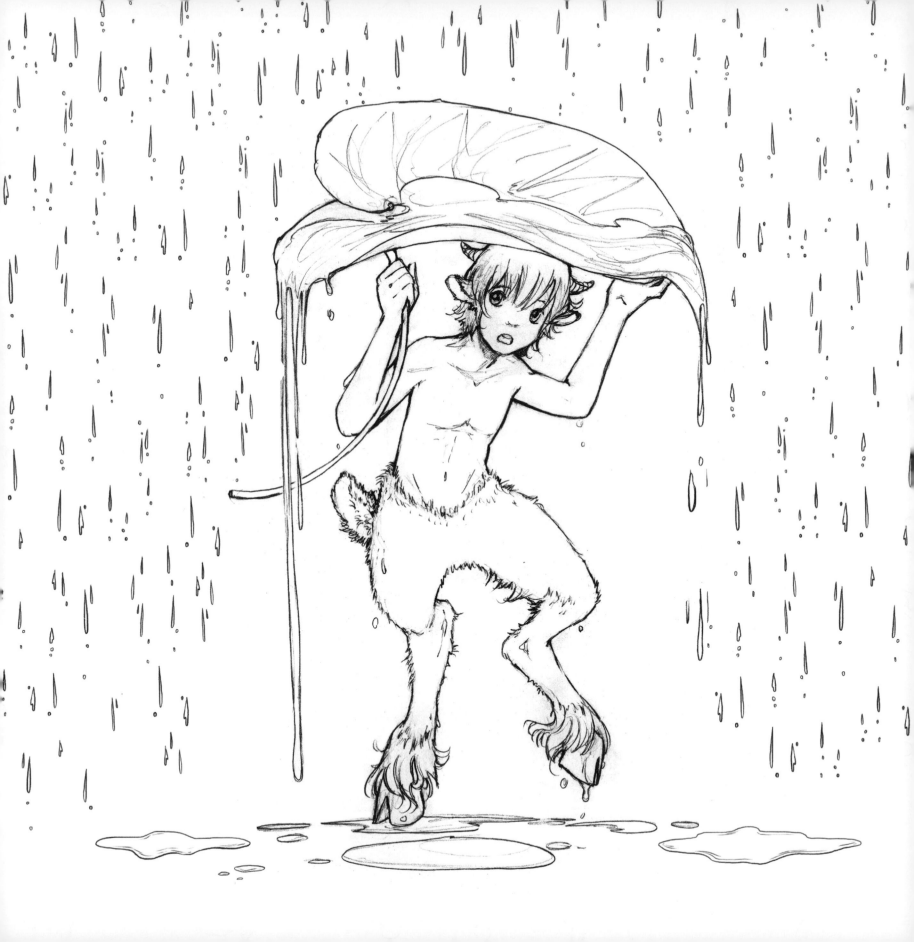

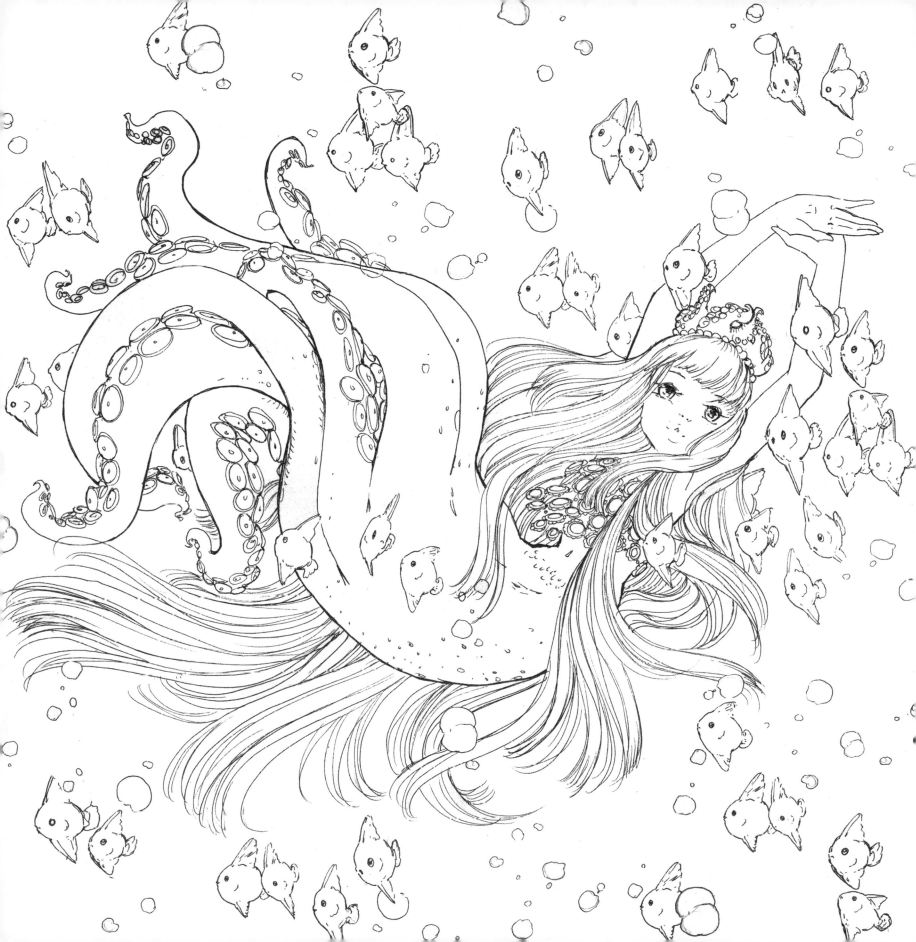

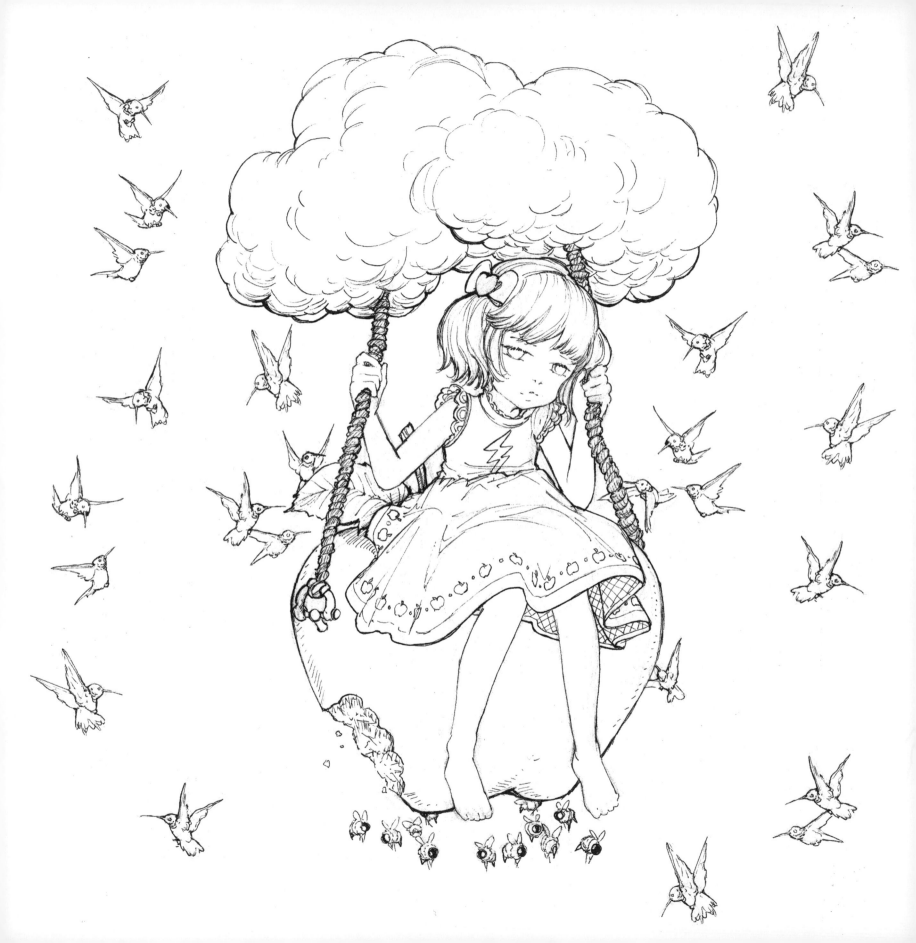

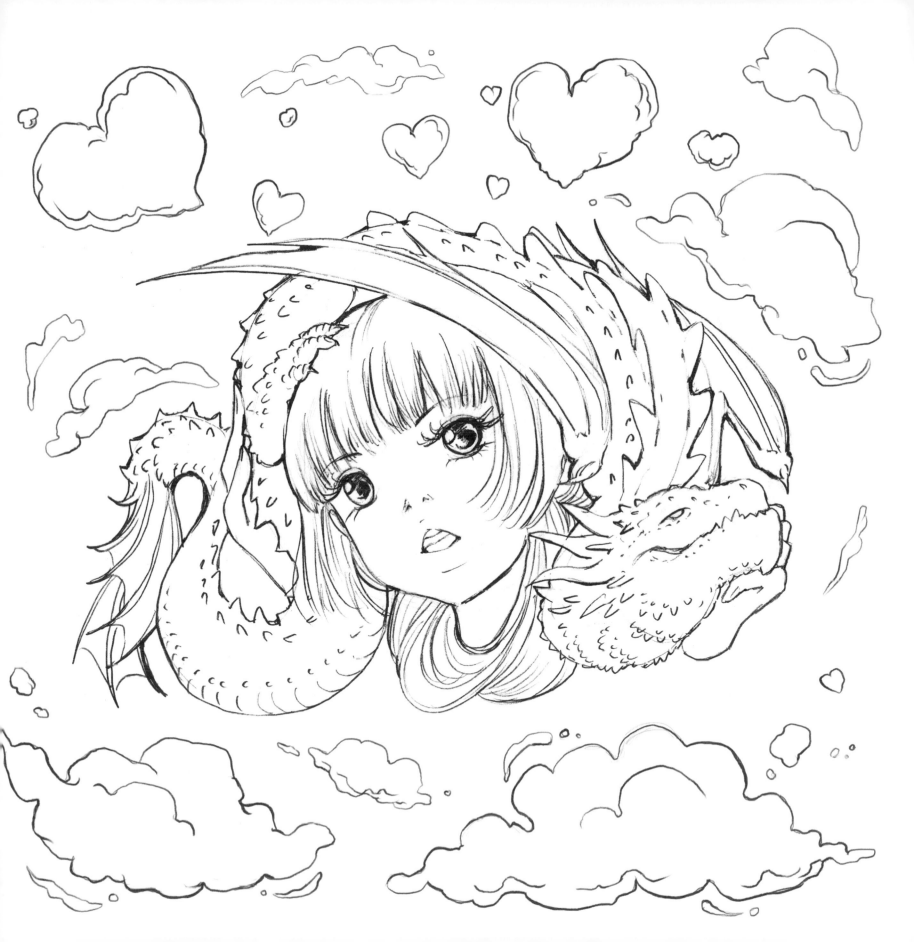

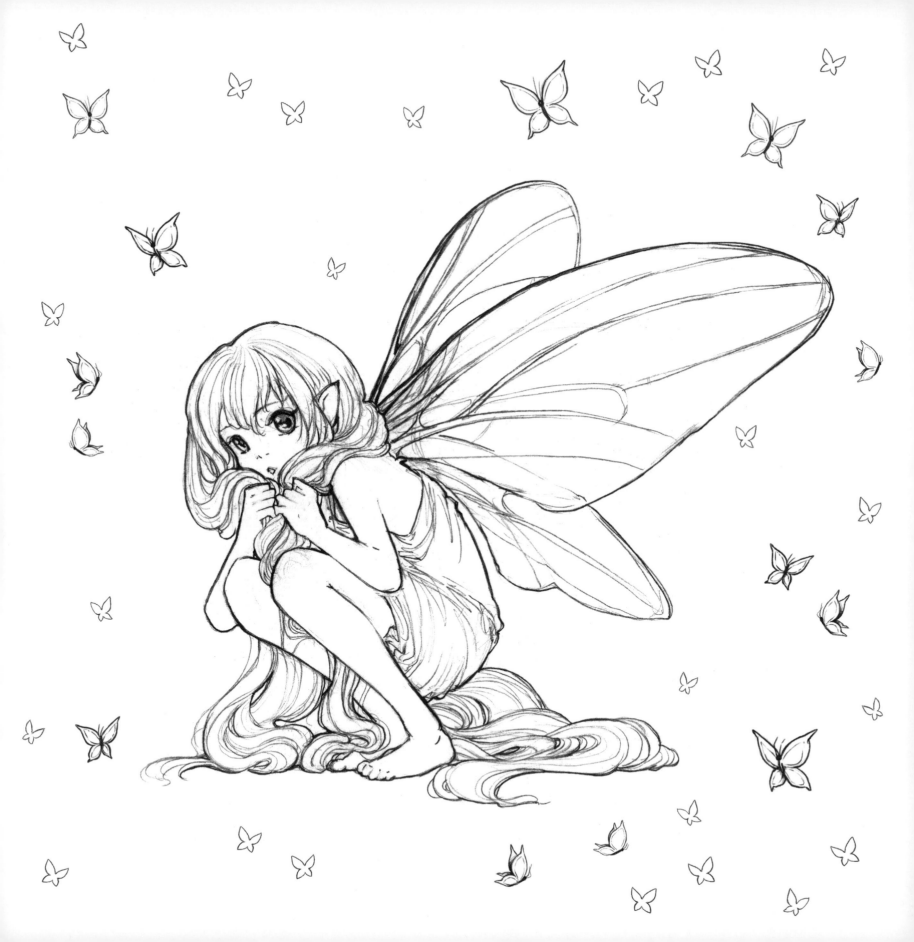

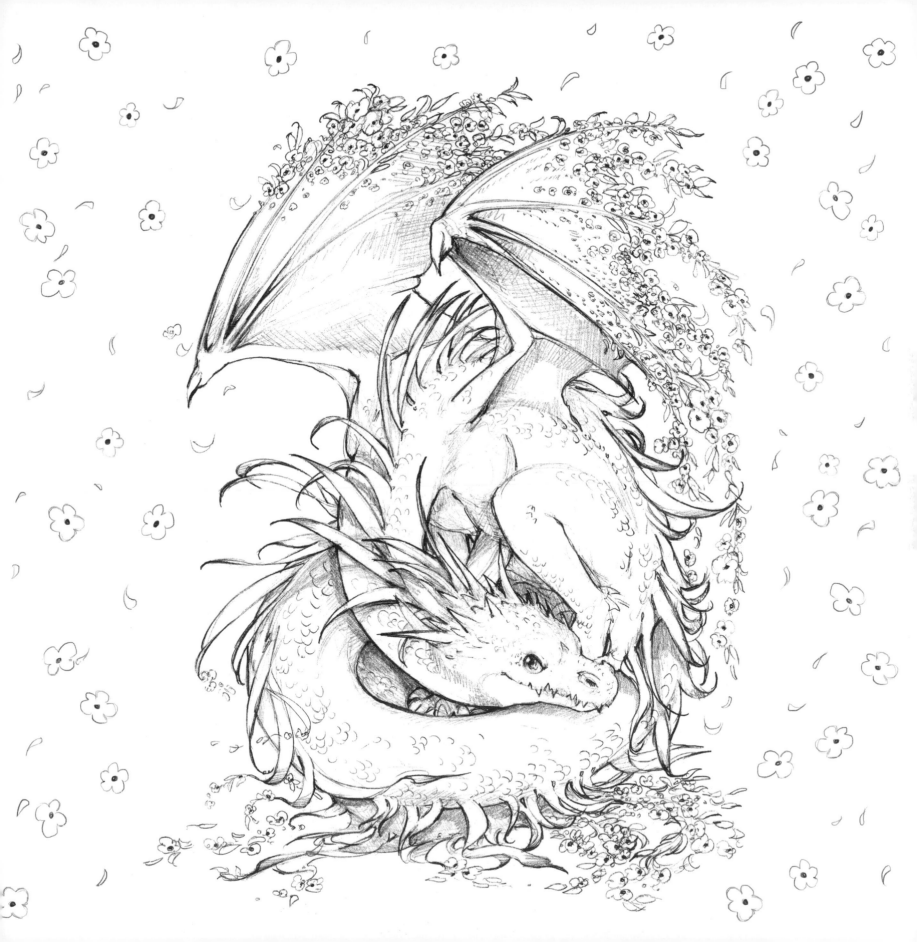

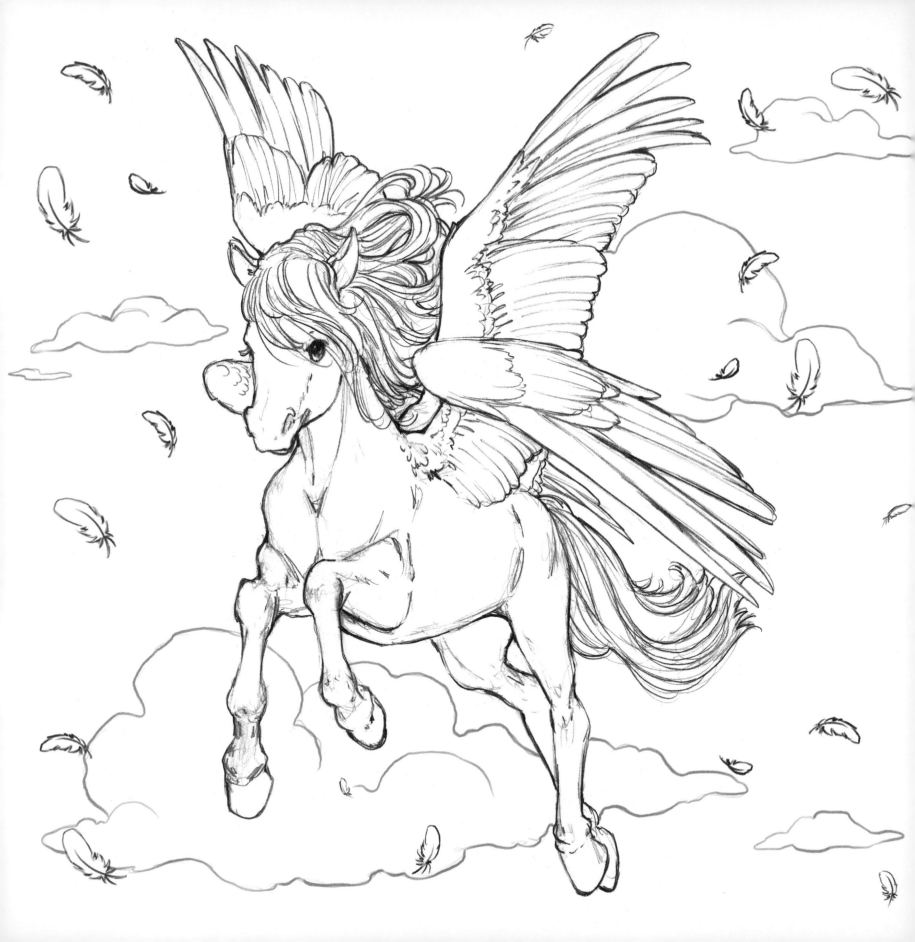

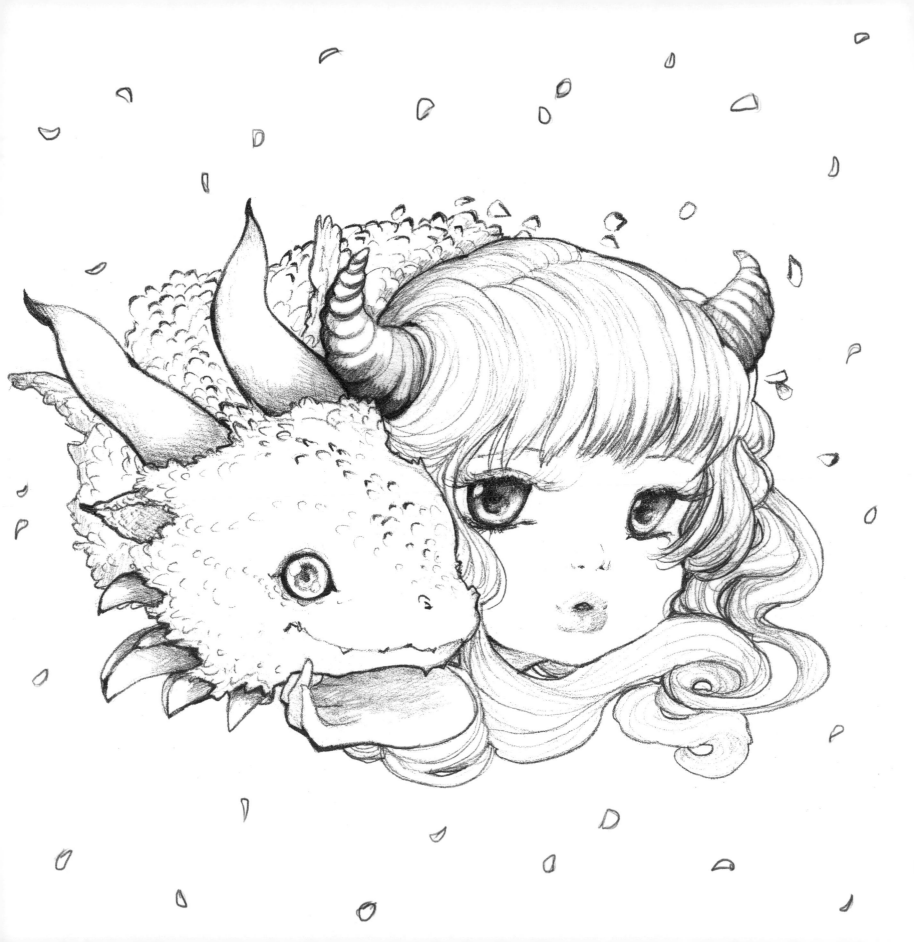

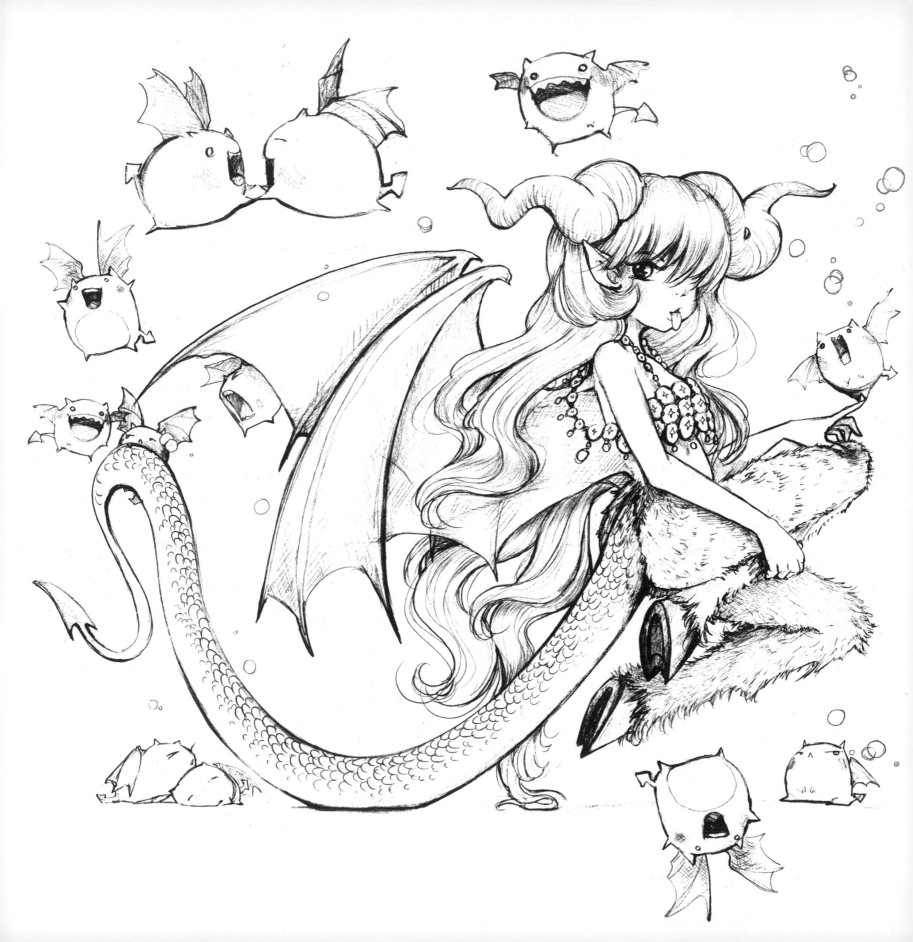

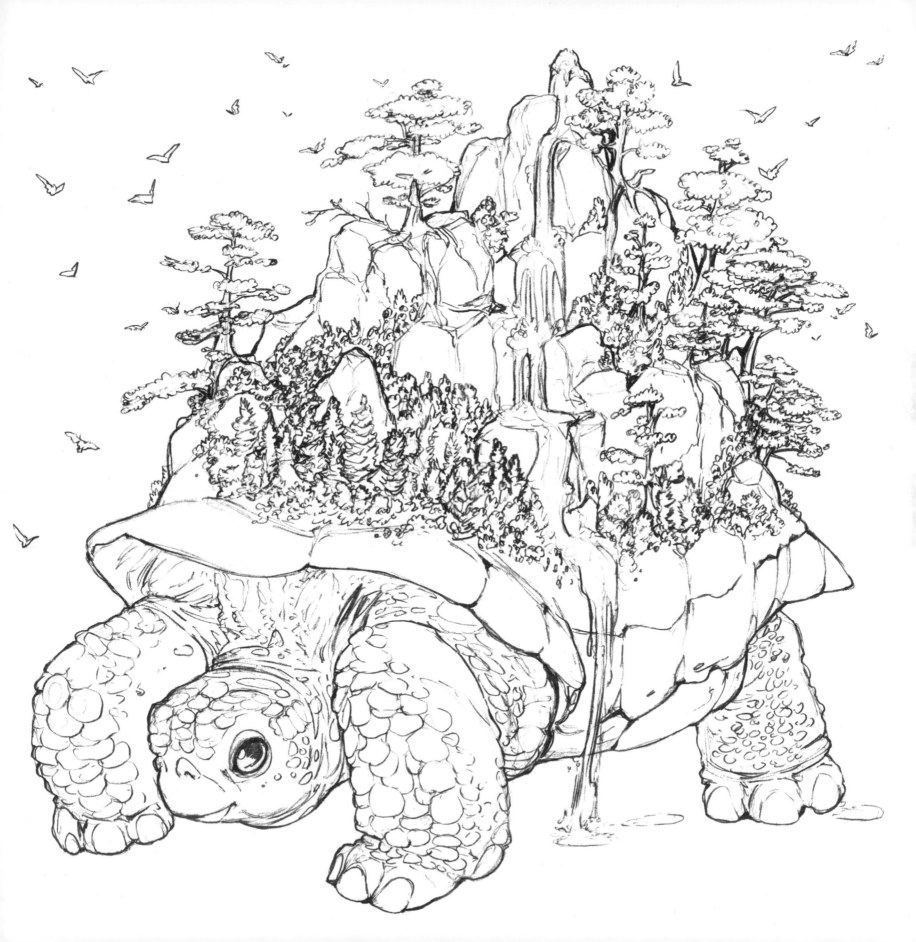

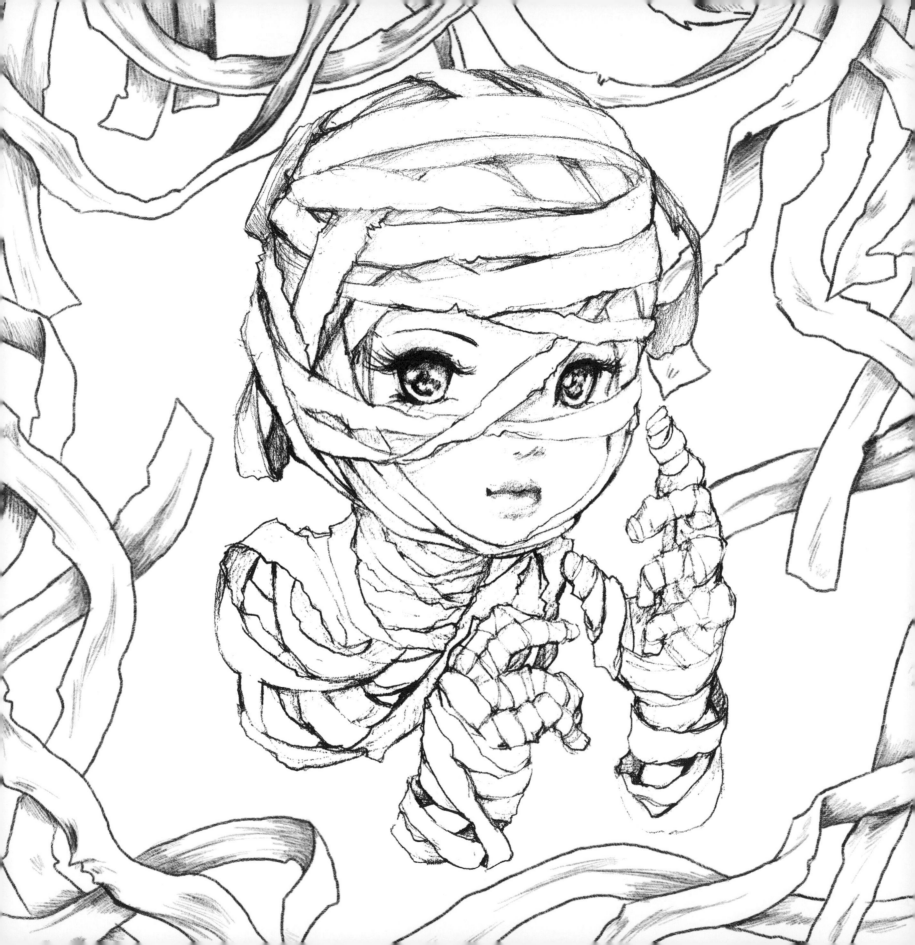

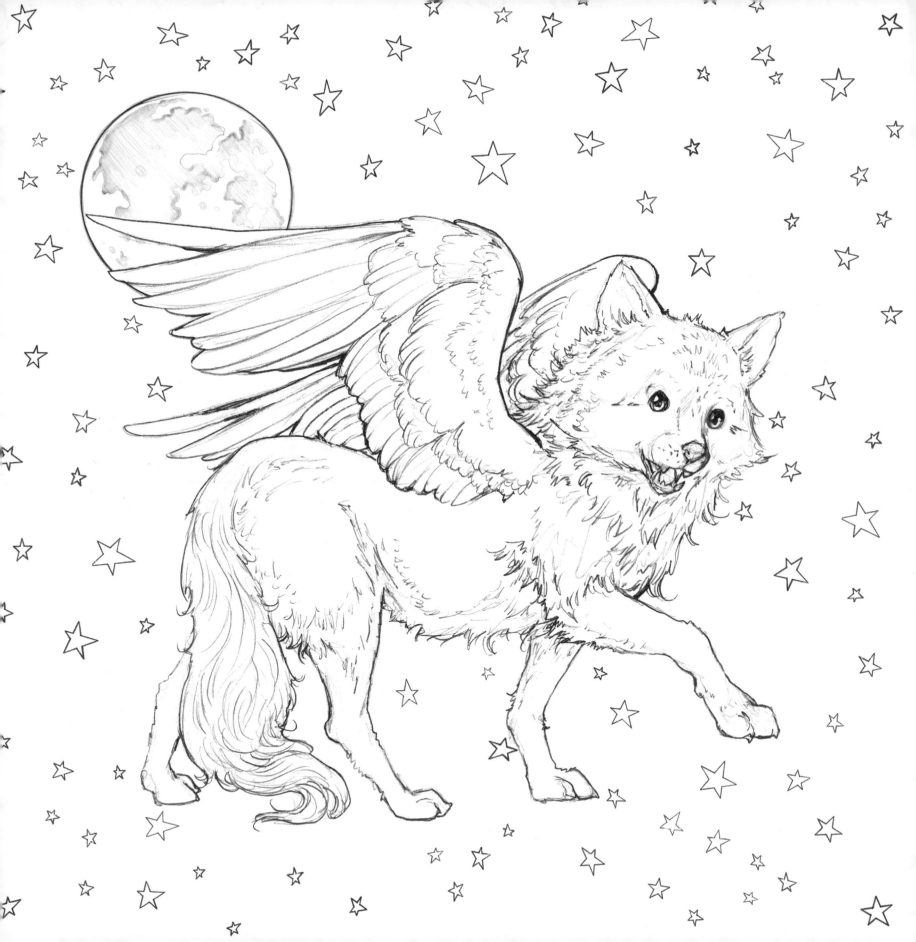

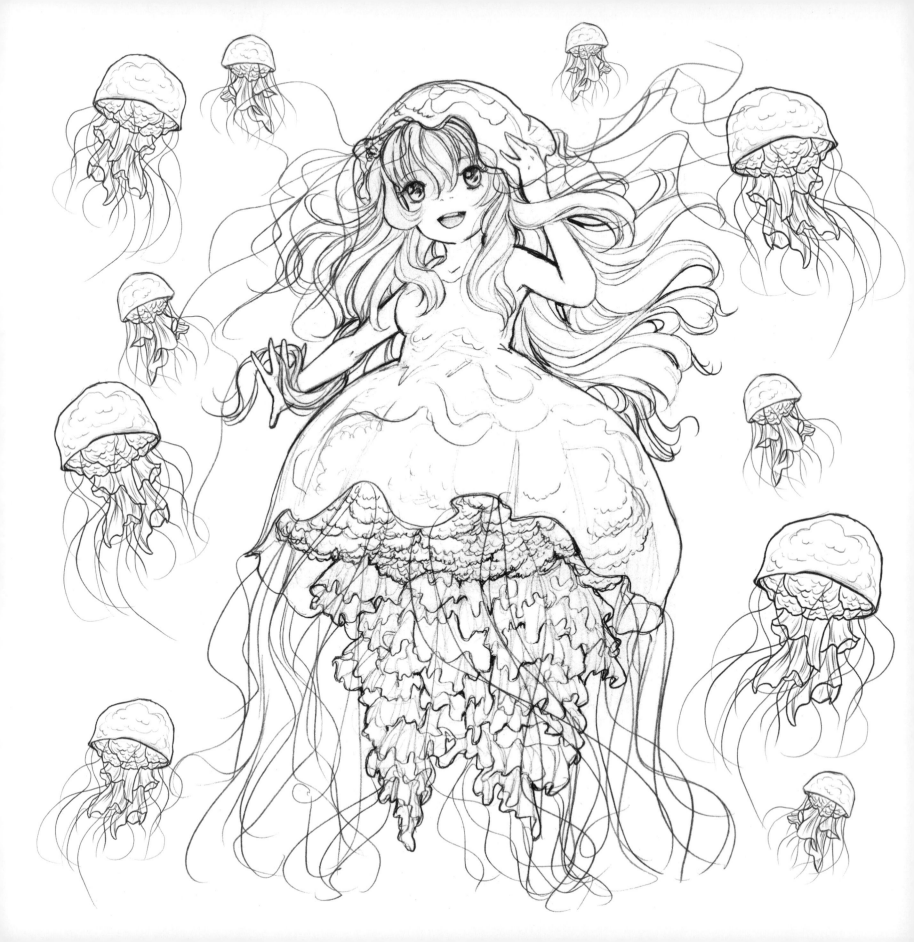

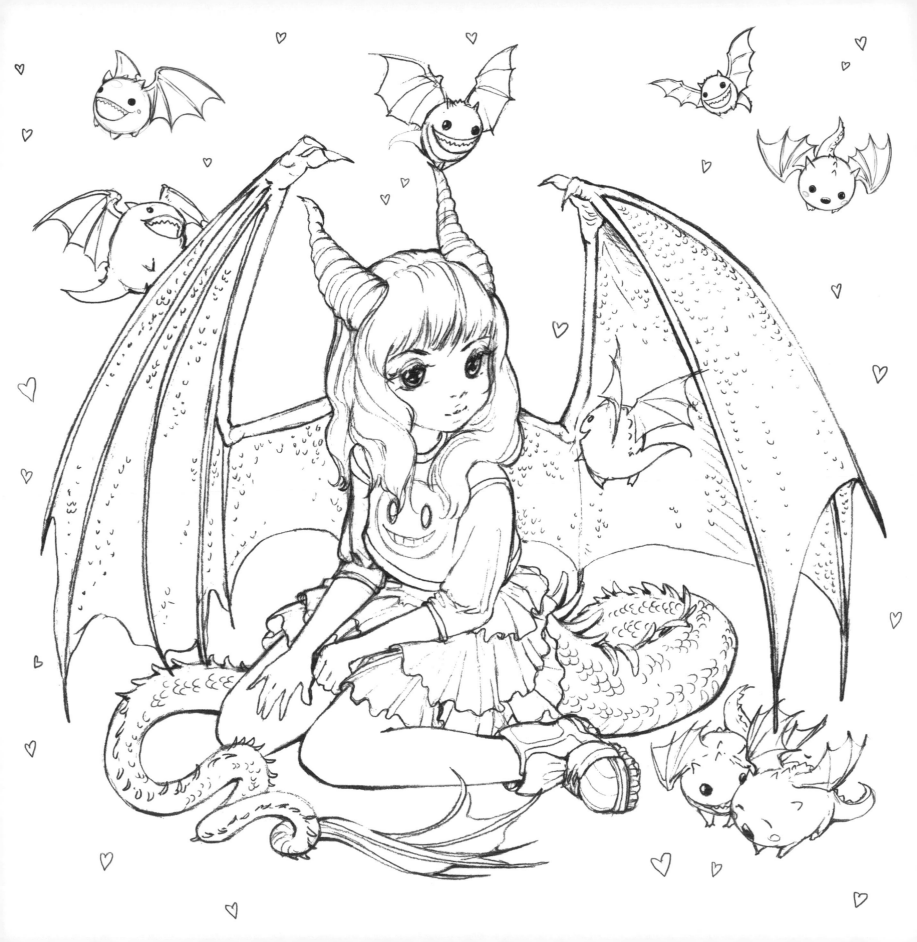

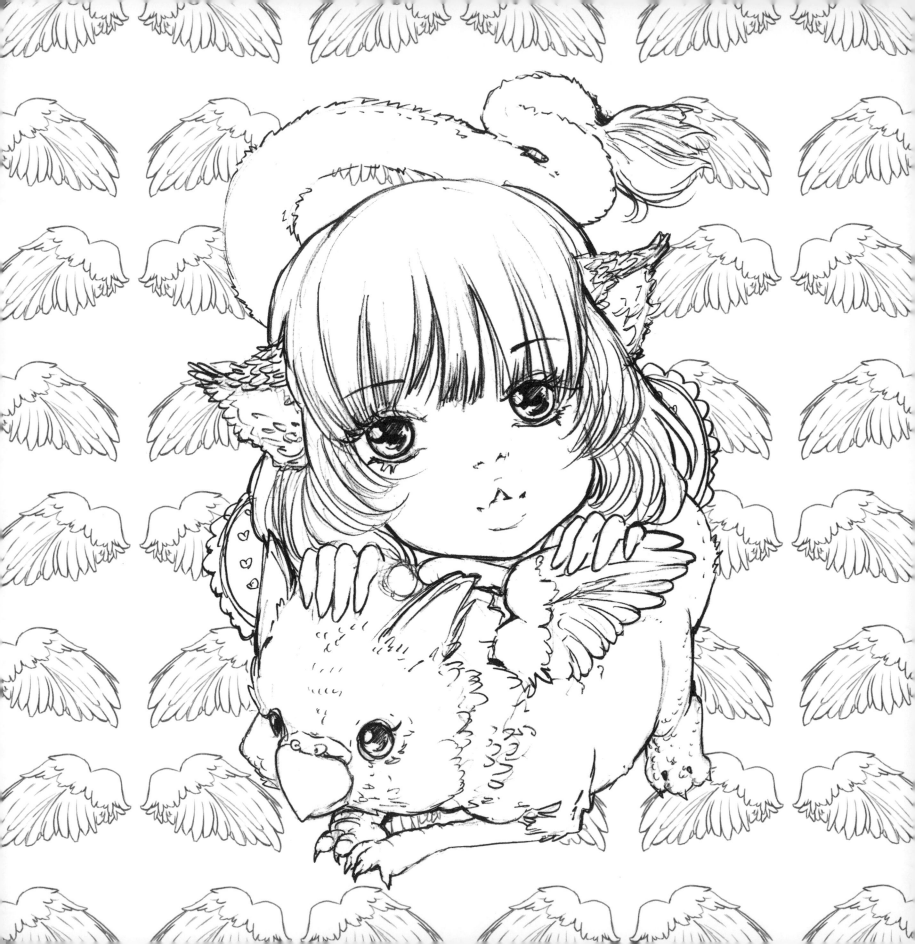

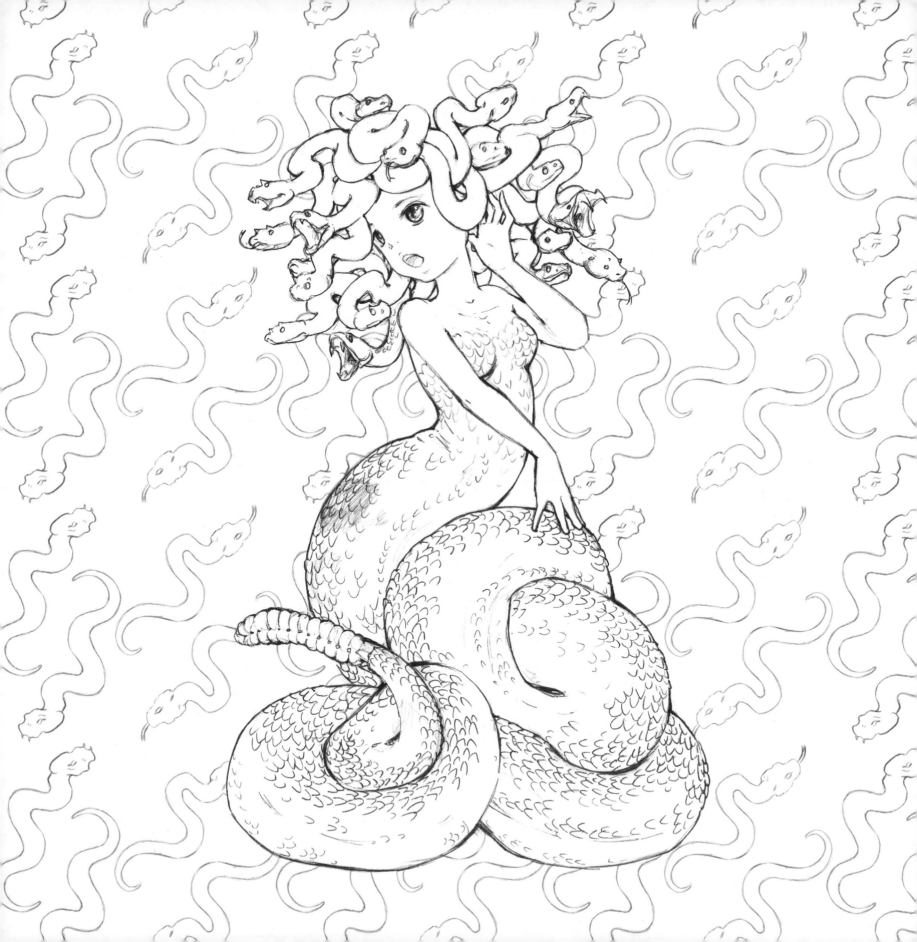

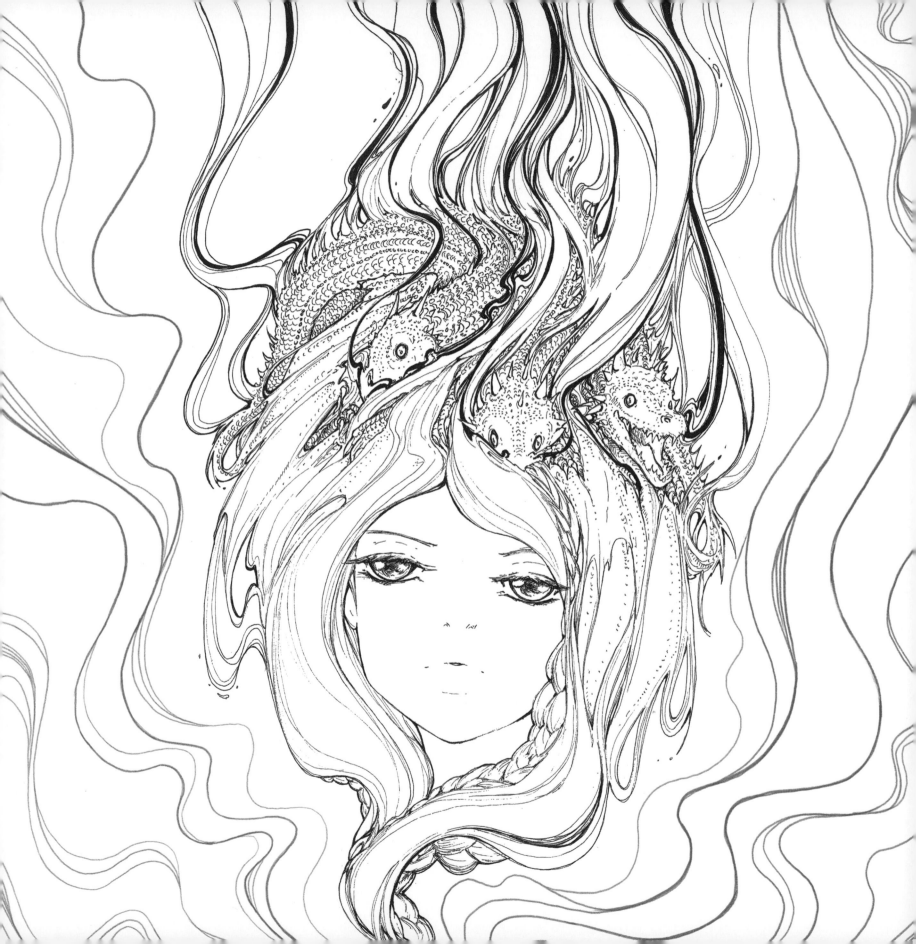

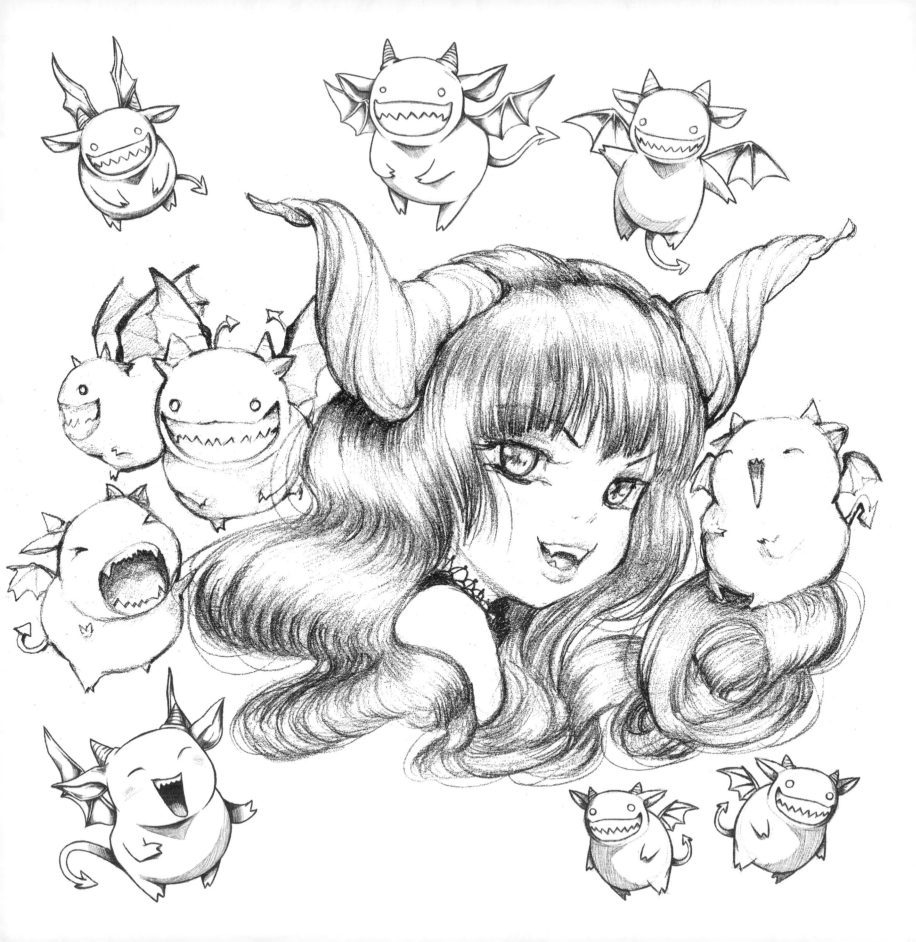

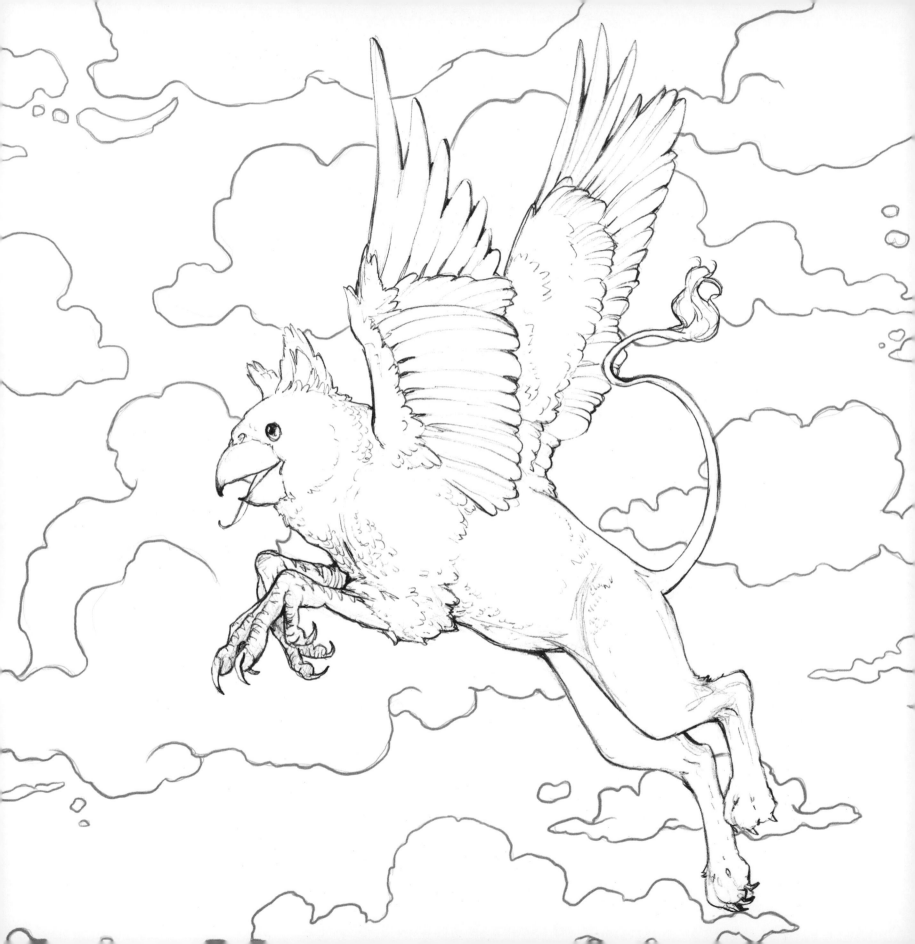

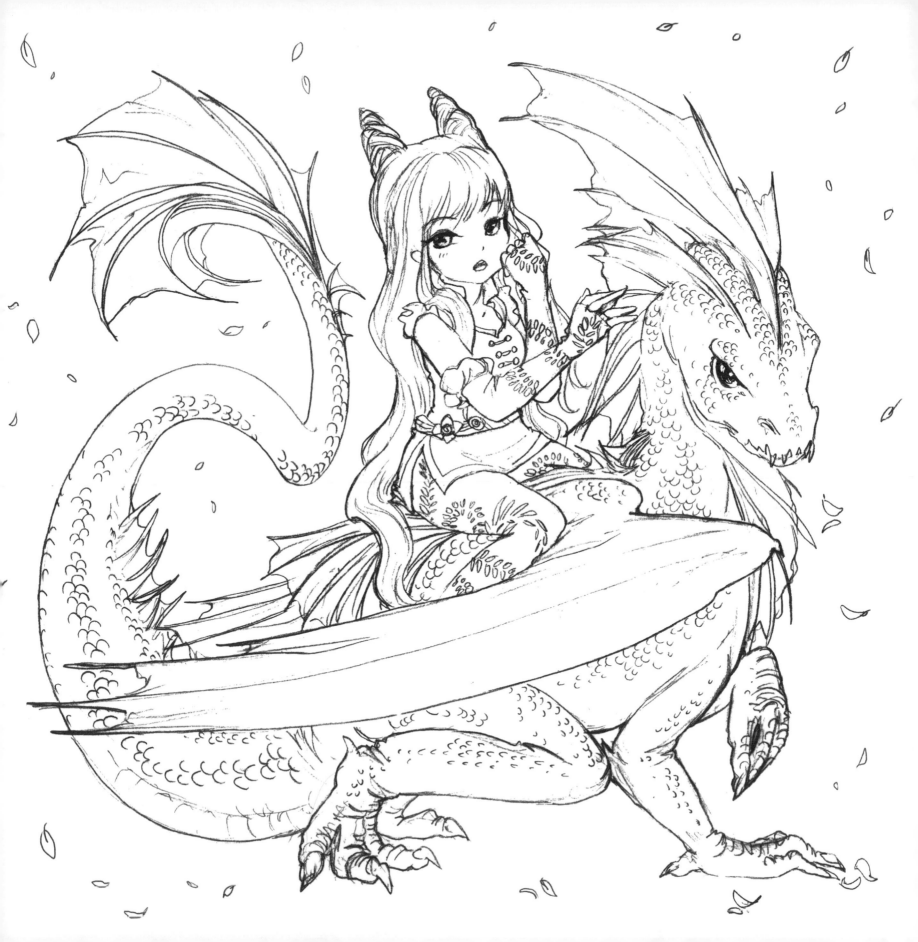

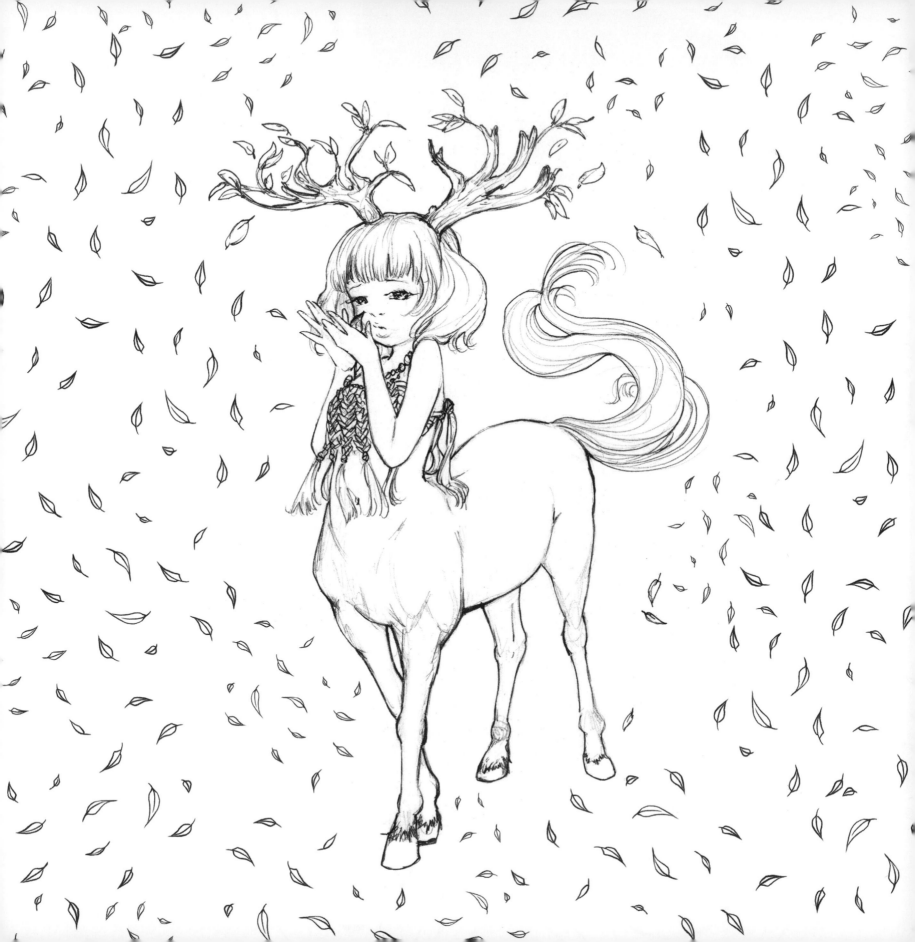

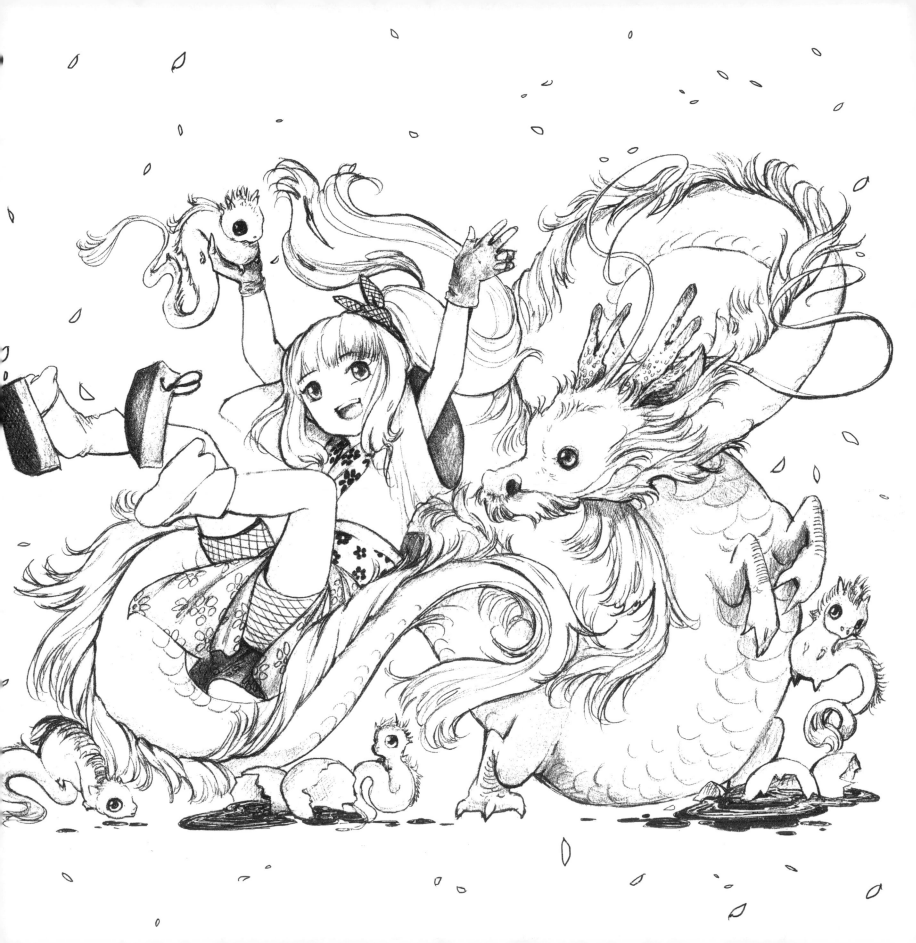

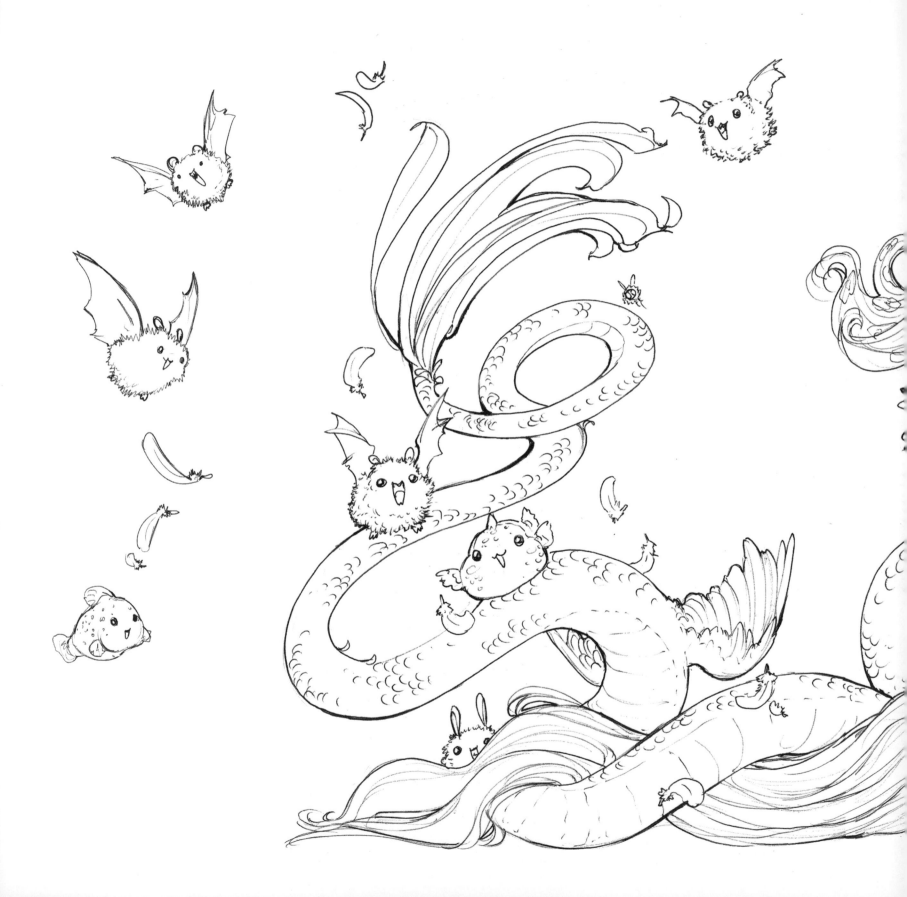

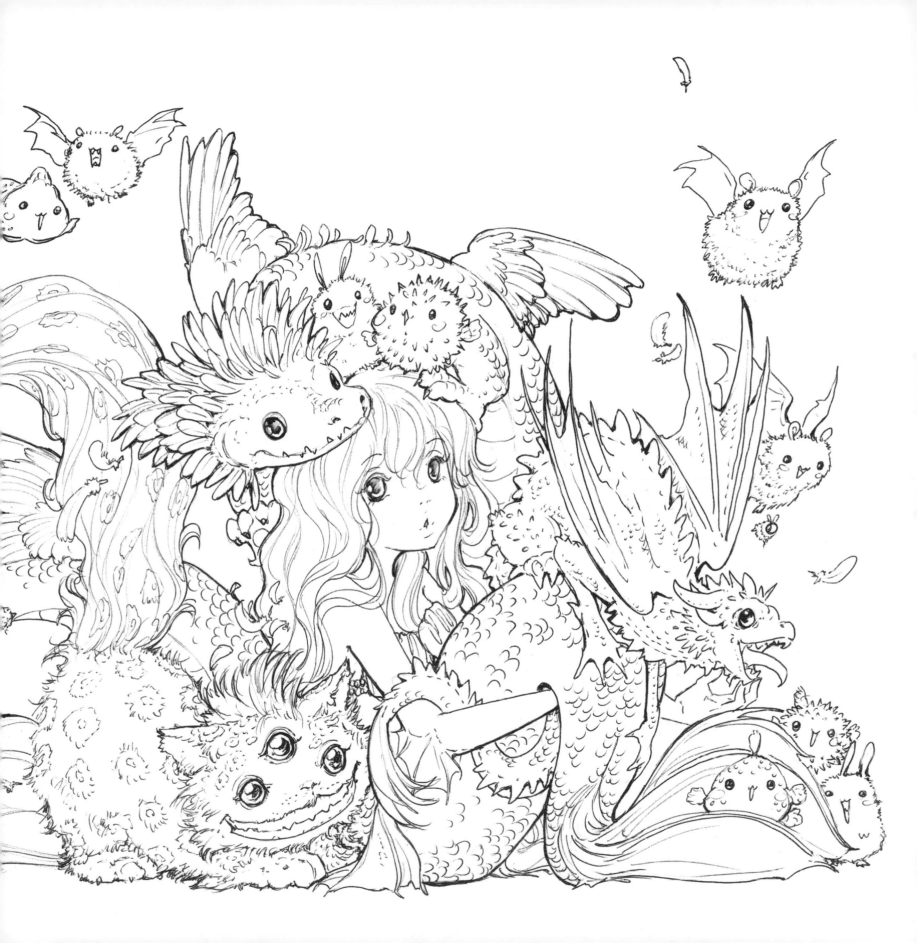

Compilation copyright © 2023 by Camilla d'Errico

All rights reserved.

Published in the United States by Watson-Guptill
Publications, an imprint of Random House, a division
of Penguin Random House LLC, New York.
WatsonGuptill.com
RandomHouseBooks.com

Watson-Guptill and the Horse Head colophon are
registered trademarks of Penguin Random House LLC.

The illustrations in this work were originally published
in the following works by Camilla d'Errico and published
by Watson-Guptill Publications, an imprint of Random
House, a division of Penguin Random House LLC:
Pop Manga Coloring Book (2016), *Pop Manga Mermaids
and Other Sea Creatures* (2018), *Pop Manga Cute and
Creepy Coloring Book* (2020), and *Pop Manga Dragons
and Other Magically Mythical Creatures* (2022).

Typeface: HVD Fonts's Brandon Text

Trade Paperback ISBN: 978-1-9848-6276-1

Printed in China

Acquiring editor: Kaitlin Ketchum | Project editor: Zoey Brandt
Production editor: Natalie Blachere
Designer: Nicole Sarry | Art director: Betsy Stromberg
Cover color: Omar Francia | Production manager: Dan Myers
Project facilitator: Ri Shaw | Marketer: Monica Stanton

*The author gratefully acknowledges Savanna Reardon-Cannaday
for her design work and dedication to this project.*

10 9 8 7 6 5 4 3 2 1

First Edition